20TH CENTURY DRAWINGS · PART I

DRAWINGS OF THE MASTERS

20TH CENTURY DRAWINGS
PART I: 1900-1940

Text by Una E. Johnson

LITTLE, BROWN AND COMPANY **L|B** BOSTON · TORONTO

COPYRIGHT © 1964 BY SHOREWOOD PUBLISHERS, INC.

ALL RIGHTS RESERVED. NO PART OF THIS BOOK MAY BE REPRODUCED IN ANY FORM OR BY ANY ELECTRONIC OR MECHANICAL MEANS INCLUDING INFORMATION STORAGE AND RETRIEVAL SYSTEMS WITHOUT PERMISSION IN WRITING FROM THE PUBLISHER, EXCEPT BY A REVIEWER WHO MAY QUOTE BRIEF PASSAGES IN A REVIEW.

A

LIBRARY OF CONGRESS CATALOGING IN PUBLICATION DATA

Johnson, Una E
 20th century drawings.

 Reprint of vol. 1 of the 2 vol. ed. published by Shorewood Publishers, New York, in series: Drawings of the masters.
 Bibliography: p.
 1. Drawings. I. Title. II. Series: Drawings of the masters.
[NC95.J6 1976] 741.9′4 75-25734
ISBN 0-316-46759-6

Published simultaneously in Canada
by Little, Brown & Company (Canada) Limited

PRINTED IN THE UNITED STATES OF AMERICA

Contents

ARTISTS AND FIGURES IN TEXT

ARTISTS AND PLATES

20TH CENTURY DRAWINGS
PART I

The art of drawing, an intimate, subtle, often searchingly personal statement, is the pinning down of an idea or mood in visual form within a given space. Drawing underlies every form of pictorial or plastic expression and usually designates a beginning stage in the creation and development of a work of art, whether it be painting, sculpture, architecture, prints or other visual expressions.

Drawing has a much wider function than the mere description of an immediate image. It closely charts or symbolizes the ideas and meditations of an artist. In fact, it is the artist's own exacting shorthand or discipline, which crystallizes his thoughts and observations. Distortion and brevity, exaggeration and understatement often emphasize a single image. The entire mood or idea may be clarified through the quality of a drawn line. This is apparent through its measured grace or coarseness, its tautness or limpid placidity, its nervousness or its abrupt fluctuations. Henri van de Velde made the penetrating observation that line is a force and borrows its energy from that of the man who draws it. It is well to remember that great drawings are seldom exact in their proportions. In their drawings, artists of past centuries have sought the linear boundary of a form in space and, in great measure, it is the realization of this fine, linear edge that gives character and authority to a drawing. Achieved by means of pen, brush or pencil, the resulting image may be set down quickly or painstakingly, with deliberation or with spontaneity. However, the artist in the present century has often shattered the linear edge and exploded forms into many-sided facets of movement, energy and intensity in his pursuit of a reality beyond the concrete or recognizable image. This headlong preoccupation has led him on many strange and exploratory jour-

neys in his attempt to bring into visual focus his experiences, his questionings and his innermost feelings.

A half century that has witnessed two world wars, a major economic depression and the unlocking of the atom with its uneasy consequences has been a disquieting one. Existential theories and themes, the challenge of the arcane knowledge of Buddhist precepts and exposure to the tide of social and political upheavals are only a few of the ideas and problems that confront thinking and judgments in the twentieth century. The artist, the writer and the composer, among others, have sometimes turned to a private world which may be enjoyed only by those who are willing or determined to seek it. Nevertheless, the new discoveries of space and imagination are being explored by the artist as well as the scientist and philosopher. In a new and swiftly-changing landscape the artist must work out an idiom of expression consistent with his own temperament and experience. This may be through realism, expressionism, super realism or abstraction so long as it is pursued with conviction and purpose.

There are numerous ways of classifying drawings. One has been effectively developed in the field of art criticism and connoisseurship by Arthur Pope in his treatise *The Language of Drawing and Painting.*[1] He has designated three modes of drawing and distinguished them as delineation or line drawing, form drawing and color-value drawing. He hastens to state that this designation cannot be precise because of the great variations within a mode and the blending of different modes within a single composition. However, this tentative structure serves as a means for a clearer perception and understanding of the possibilities of expression through drawing and as a general basis for the judging of quality in examples of this medium.

Perhaps one of the most immediately satisfactory classifications, and one in which the artists' own attitudes and efforts may best be understood is the following:

1. Pope, Arthur, *The Language of Drawing and Painting.* Cambridge, Mass., 1949, pp. 56-73.

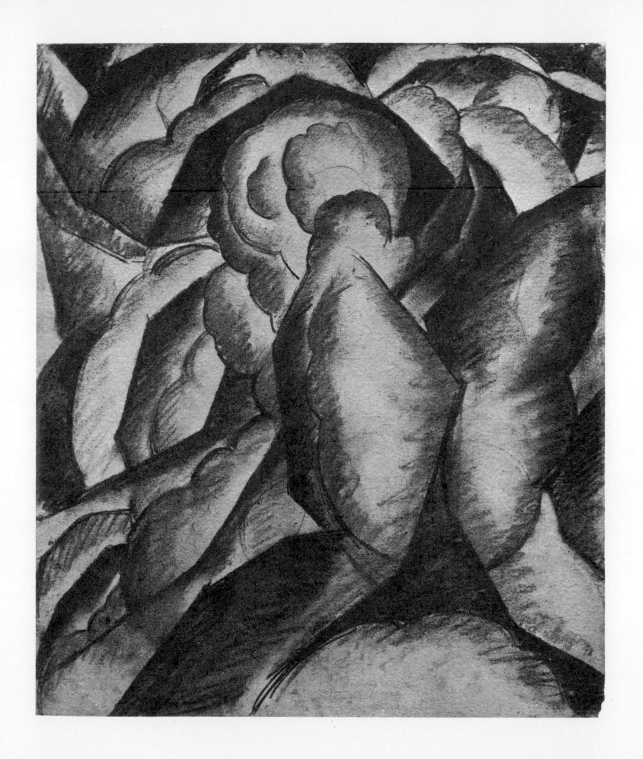

1. The preliminary sketch for a painting, sculpture, etc.

2. The unpremeditated sketch or drawing, including artists' sketchbooks.

3. The complete compositional drawing which may or may not have been intended as such by the artist.[2]

In the preliminary drawing the artist seeks to suggest or define an image. He may make only a few sketches or he may carry out hundreds—all building up to his final statement. He is dependent upon his draughtsman's ability to select, to correct, to overstate or to modify the elements of the basic image. For example, Picasso made countless studies before he began to paint the epoch-making Cubist work *Les Demoiselles d'Avignon*. He spent several years in producing literally hundreds of sketches and prints which finally led, in 1937, to the formidable and powerful painting, *Guernica*.

The unpremeditated sketch, sometimes called the occasional sketch or drawing, is more elusive. Here the artist sets down whatever happens to arrest his attention or intrigue his imagination. These sketches often are held for future use, to be incorporated into some yet undesignated work. Lyonel Feininger eloquently states: "To file many hundreds of sketches stored haphazard in portfolios revives unforgettable circumstances, places and attitudes of years past. The runes of these pages resemble seeds full of magic capable of germinating into future works."[3]

Artists' sketchbooks are filled with such graphic comments and constitute very personal journals. Henri Focillon, in *The Life of Forms in Art*,[4] suggests that "we consider drawings, which give us the joyful sense of fullness with the greatest economy of means—little substance almost imponderable. None of the resources of underpainting are here, no glazes or impasto, none of the rich variations of brushwork which give brilliance, depth and movement to painting. A line, a spot on the emptiness of a white sheet flooded by light: no yielding to technical artifice, no dawdling over a complicated alchemy. One might say that spirit is speaking to spirit. And yet the full weight

2. Wheeler, Monroe and Rewald, John. *Modern Drawings*. New York, Museum of Modern Art, 1944, pp. 9-10.
3. Feininger, Lyonel. *Drawings*. New York, 1951, unpaged [5].
4. Focillon, Henri. *The Life of Forms in Art*. New York, 1948, pp. 73-74.

of the human being is here in all its impulsive vivacity and with it is the magic power of the hand...[which] finds every instrument useful for writing down its signs. It fashions strange and hazardous ones; it borrows them from nature —a twig, a bird's feather....With unheard of assurance it exploits the resources of an age-old science; but it exploits also an unpredictable element beyond the realm of spirit, that is to say, accident." It is thus that Focillon describes the sketchbooks of artists and calls them "the diary of the human hand."

The third category, the complete compositional drawing, may be in itself the artist's final statement. It is carefully placed on the sheet of paper and the basic idea is carried to its conclusion. Such drawings are often held by the artist, and he may return to them for inspiration at some later time, thereby giving an underlying continuity to the various periods of his formal work. Many modern painters and some sculptors have made complete compositional drawings. Among Henri Matisse's extensive graphic work are many such compositions. His early drawing *Nude in a Chair,* ca. 1906, showed a new freedom in its expressive distortion. This masterly sense of composition and movement was fully realized in his later drawings in the period from 1939 through World War II.

It is of interest to consider that Matisse, one of the great colorists of the twentieth century, confined himself in all his drawings to the strict discipline of black and white. Nonetheless with pen, pencil and brush he achieved elegant subtleties that might be expected through a deft use of color. Matisse sums up his assiduous devotion to drawing in a statement in *Le Point* in 1939: "I have always considered drawing not as an exercise of particular dexterity but as above all, a means of expressing intimate feelings and moods, a means simplified to give greater simplicity and spontaneity to expression, which should speak without heaviness directly to the mind of the spectator."[5]

To be considered with Henri Matisse and in the French tradition of sensitive draughtsmanship are the drawings of Georges Braque. His sketchbooks,

5. "Notes d'un peintre sur son dessin." *Le Point,* no. 21: July, 1939, 104-10.

Figure 2
Otto DIX · *Sketch for a War Painting, 1917* · pencil
19 x 18 inches · Ulm-Donau, Ulmer Museum

reflecting his mature style, extend from 1917 through the 1940's. They are visual lyrics, often transporting into a twentieth-century idiom the lively grace and draughtsmanship of early Greek vase painting. Unmistakably French, Braque, like Bonnard, has maintained throughout his work an integrity and coherence of style. For Braque the line or a leaf of a moving figure becomes an image magnificent in its balance and measured cadence. He has chosen to make but few remarks about his work preferring to let his drawings and paintings speak for themselves. Braque believed that "limitation of means determines style, engenders new forms and gives impulse to creation."[6]

It may be noted briefly that the above categories of drawings have in common conventional materials and tools:

1. Pen and ink and occasionally a wash.
2. Brush with ink, oil or water color.
3. Pencil, charcoal, black or red chalk.
4. Metalpoint on paper usually prepared for the purpose.[7]

In his pursuit of the reality of objects and ideas the artist often resorts to other than conventional means of pencil, pen or brush. He may use a broken to two-pronged pen, a shredded stick, a worn stub or a brush or a sponge to spread a wash over a clear sheet of paper. Such combinations do not merely exploit unusual lines and forms and limitless perspectives but serve to give substance to a fleeting vision or a quick perception. These informal tools in the hands of an artist permit him to search for and occasionally to extend through intuitive means the vocabulary of lines and forms into a revelatory vision.

The history of art records a continuing revolt against prevailing or outworn modes of expression. Although the Impressionists and Postimpressionists were featured in the Great World Exposition in Paris in 1900, a revolt against their point of view and their style was evident among the younger painters. The means the latter employed were violent distortion of natural

6. Arts Council of Great Britain. *G. Braque. An Exhibition of Paintings.* Foreword by Douglas Cooper. Tate Gallery, London; Royal Scottish Academy, Edinburgh, 1956, pp. 10-11.
7. Popham, A. E. *A Handbook to the Drawings and Watercolours in the Department of Prints and Drawings.* London, The British Museum, 1939, p. 10.

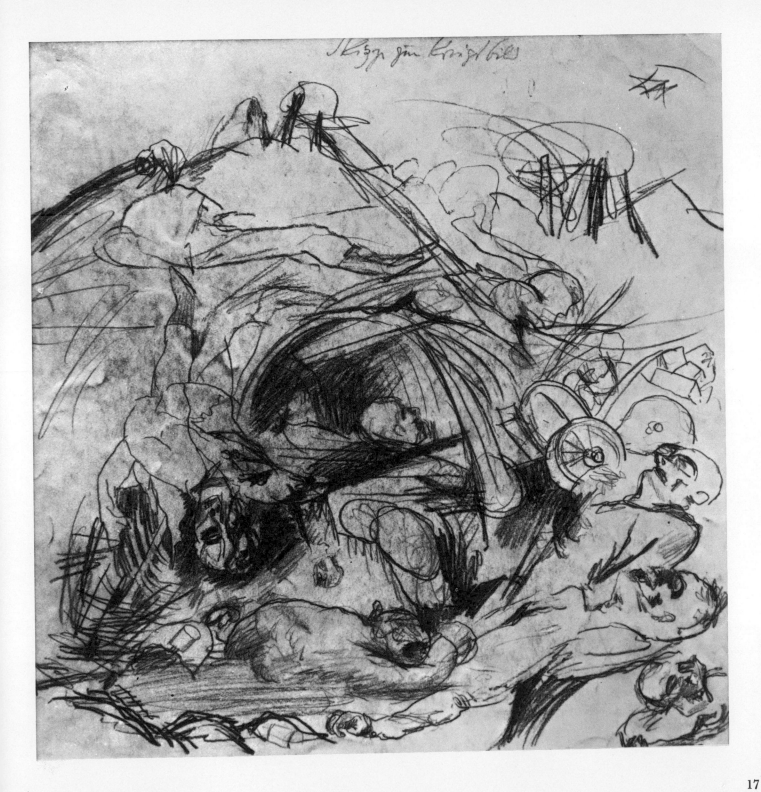

17

forms and strong areas of pure color. Never a cohesive or formal group, their brief existence centered around Henri Matisse, and their common meeting place was the studio of Gustave Moreau. They were, in fact, expressionists who rebelled against the splitting up of color and disintegration of forms. They became known as Les Fauves, or the "wild beasts"—first so-called by contemporary art critics. The principal artists identified with this growing change in visual forms were Matisse, Braque, Derain, Friesz, Vlaminck, Rouault and Dufy. For a brief time the work of the Fauves and the experiments of Die Brücke, a comparable group in Dresden, ran a somewhat parallel course. However, many French artists and those identified with the French group soon turned to a still more radical and fundamental change in the development of twentieth-century art known as Cubism.

Nearly all the artists from other countries in Europe and from the United States and Mexico either visited or studied in Paris during the late years of the nineteenth and first decade of the twentieth century.

Among the artists born in or near Paris were Derain, Rouault, Picabia and Delaunay. Furthermore, many other native French artists from the various provinces were drawn to Paris during their early years, including Matisse in 1891, Braque, Léger, Dunoyer de Segonzac, Marcel Duchamp and Jacques Villon, to mention a well-known few. Feininger, who had gone from the United States to Germany as a music student in 1887, first visited Paris in 1891 and again in 1906. Nolde, Paula Modersohn-Becker and Franz Marc came from Germany. Paul Klee came from a previous sojourn in Dresden and Brancusi from Munich. Picasso and Gris arrived from Spain—Boccioni, Carrà, Modigliani and Severini from Italy. From Russia were Kandinsky and Chagall and the "Munich Russians," Lissitzky and Jawlensky. From America were Max Weber, Alfred Maurer, Marsden Hartley and Arthur Dove; also John Marin, although his participation in the new expression and styles of the twentieth century did not occur until his return to the United States in 1911.

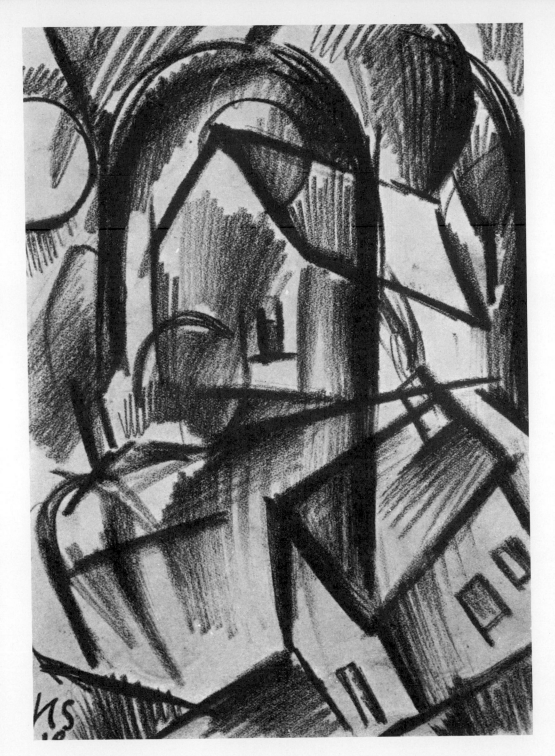

Figure 3
Kurt SCHWITTERS
Houses, 1918
charcoal, 7⅜ x 5⅛ inches
New York, Dr. Charlotte Weidler
Photo courtesy of
Galerie Chalette, New York

Where the Fauves had been greatly influenced by and drew heavily from their predecessors, Cubists Picasso and Braque by-passed tradition and began a new visual language of their own. Thus a new analysis of the fundamental elements of form, space and the obliteration of traditional perspectives and the single source of light was underway. Light and dark patterns were spread over the composition in a splintering effect of the objects or figures. A new order of forms presented with little or no concern for the natural object gave a new dynamism through its multiple views. In their efforts to reveal the basic structure the Cubists often reduced color to an inconsequential level.

Cubism as a formal movement in art began in 1907, the year of the Cézanne Memorial Exhibition in Paris. Perhaps it was Cézanne's painstaking search for a new life in the basic forms of his motif that led to such revolutionary vision. The originators of Cubism were Picasso and Braque. Others identified with the movement in its early development were Juan Gris, Fernand Léger, Robert Delaunay, Albert Gleizes and Francis Picabia. It is generally agreed that the most radical movements in art since the Renaissance came into being through those artists identified with the cubist movement and through the expressionist artists of Die Brücke. Stylistically Cubism had a coherence that continued long after the artists directly identified with it had turned to other visual problems. The ferment of change and exploration went on not only in Paris but also in Dresden, Munich, Berlin and Milan. In the burgeoning movement of Expressionism, Germany made its first great contribution to twentieth-century art. A small nucleus of architectural students in Dresden in 1905 became actively interested in painting and print-making. Under the leadership of Ernst Ludwig Kirchner, Eric Heckel, Karl Schmidt-Rottluff and Max Pechstein launched a new and vigorous movement known as Die Brücke. Later joined by Emil Nolde, August Macke and others, they occupy a key position in the growth of modern expressionism.

Kirchner, recalling his earlier studies of Rembrandt's and Dürer's work at the Munich Cabinet of Engravings remembered: "They taught me how to

arrest a movement in a few bold lines. I practised this wherever I went. At home and elsewhere I made large drawings from memory catching the passing moment and finding new forms in the swift ecstasy of this work, which, without being true to nature, expressed everything I wanted to express in a bigger and clearer way."[8] Impatient with the listless, romantic style then prevailing in Germany, these artists sought new influences and new art forms. In Munich were many important exhibitions which created a fine new climate for new ideas and often startling concepts of art. They observed the paintings of the Postimpressionists, of Cézanne, Matisse, Rouault and the large comprehensive exhibitions of Oriental and Mohammedan art. Also they responded to the works of Munch, Hodler, Klimt, Kokoschka and Schiele. The discoveries and experiments of Freud, the art of children, the compulsive drawings of the mentally ill, the bold directness of primitive sculpture—all opened up new visual experiences to artist and student, to art historian and critic.

From their first small exhibition in the showroom of a Dresden lamp factory through many succeeding exhibitions, the general criticism of Die Brücke artists was violent and often unfavorable. Nonetheless these artists had taken motifs from nature and given them strong unlikely colors and harsh, insistent rhythms to create a style that was arresting in its spontaneity and forceful in its presentation of inner tensions and emotional overtones.

Their drawings are often characterized by a deliberate coarsening of the medium for the desired effect of something stark and unstudied. The heavy masses of black and white and the taut rhythms interspersed with lighter and softer lines produced a feeling of inner tension and exaggerated emotion. In their desire to bring into conscious prominence the essential emotion behind an accidental setting, Die Brücke artists often reduced faces to masks and the human figure to a grotesque form.

Die Brücke as a formal movement collapsed in 1913. However, a more far-reaching style was already taking shape in Munich under the aegis of Kandinsky. Kandinsky's own rapidly developing views about art had little in

8. Selz, Peter. *German Expressionist Painting*. Berkeley, 1957, p. 70.

common with established tradition or the aggressive realism of Die Brücke. In fact, the artists forming the new group had little in common save an over-ruling desire to carry out experiments in visual forms without any restrictions. In 1911 Kandinsky with Kubin, Marc, Munter and a few others formed a loosely-knit group under the name of Der Blaue Reiter, after a painting by Kandinsky's which held no particular significance other than its somewhat romantic implications. Klee and Campendonk joined them in 1912. Kandinsky had come to believe that nature was of significance only so far as it could be transformed to express man's inner spiritual aspects and that the true reality existed beyond the mere physical attributes of nature.

Kandinsky writes: "A perfect drawing is one where nothing can be changed without destroying the essential inner life, quite irrespective of whether this drawing contradicts our conception of anatomy, botany or other sciences. The question is not whether the coincidental outer form is violated but only if its quality depends on the artist's need of certain forms irrespective of reality's pattern."[9]

Of special note is the second exhibition brought together through the diligent efforts of Der Blaue Reiter artists. Confined to drawings, water colors and prints it turned out to be an extensive and eclectic review of the modern movements and their most pertinent characteristics. Well represented were the artists of Die Brücke, the leading French Cubists, several of the young Russian artists, the Swiss group, the Fauves, the Futurists and members of Der Blaue Reiter. Such a survey was not seen again until the infamous Degenerate Art exhibition also held in Munich some twenty-five years later under far different and shocking auspices. The abstract tendencies of Der Blaue Reiter and the gathering brilliance of Kandinsky's own original efforts in abstract expression, although interrupted by World War I, was to set the stage for generations of artists.

Many movements in art and the contributions of numerous individual artists were crowded into the years immediately preceding and following

9. Kandinsky, Wassily. *On the Spiritual in Art.* Hilla Rebay, (Ed.), New York, 1959, p. 161.

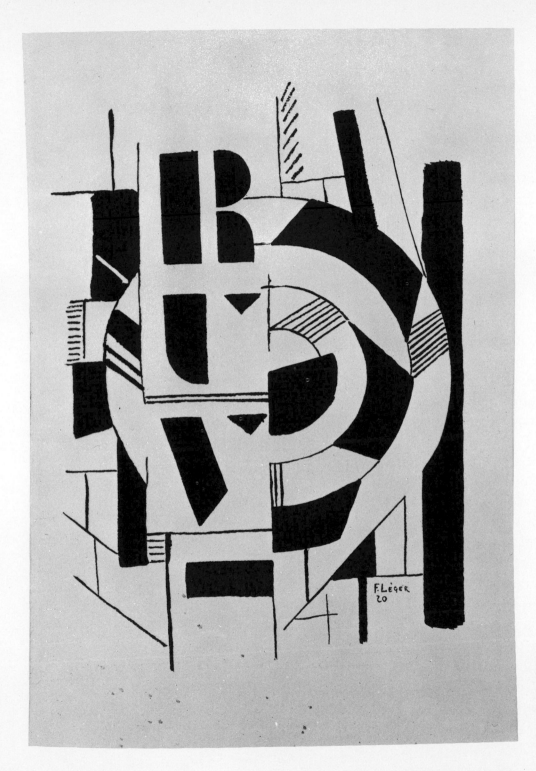

Figure 4
Fernand LÉGER
Composition RUV, 1920
pen and India ink
14⅜ x 9⅞ inches
Basel, Kupferstichkabinett

World War I. Among the most significant were the Futurists in Italy, the Neue Sachlichkeit in Germany and the surrealist artists who worked closely with the avant-garde writers in Paris after the war. The Futurists in their Manifesto of 1910 emphatically stated that a clean sweep must be made of "all stale and threadbare subject matter" to make way for a true expression of the essence of modern life. To them this was manifest in the machine, its action and speed and its repetitive rhythms. It has been observed that where the Cubists situated movement in the spectator the Futurists situated movement in the object itself. Among the most original artists of this latter group are Boccioni, Carrà and Severini. Their drawings, while they carry traces of Cubism, extend the visual impact of dynamic power, speed and movement. Their influence on the later abstract artists has been an important one.

In France, Rouault and Soutine through crescendos of color carried further the expressionist motif of the figure in evocative and persuasive symbols of their time. Rouault, a solitary figure in twentieth-century art, has been its perturbed conscience as well as its moral judge. His drawings take their place with those of Delacroix and Daumier. However, in his early cursive drawings, Rouault adds a gloomy bitterness.

In contrast to Rouault who spent most of his life in Paris, Maillol and Dunoyer de Segonzac in their very different ways reflect the southern temperament and the prevailing enchantment of Provence. Maillol, pre-eminently a sculptor, devoted a long life to the human figure as a subject complete in itself, while Dunoyer de Segonzac was most at home in the landscape of southern France where human beings adapted their lives to the tempo of the seasons.

In Germany Max Beckmann, Otto Dix and George Grosz, through the sharp, surgical brilliance of their graphic work, waged a biting attack on the moral irresponsibilities and decadence that followed the war. In their efforts to present a new definition and vision of reality they attempted to bring into being a Neue Sachlichkeit. Beckmann, a commanding figure in the years between the wars and on to his death in 1950, remarked that it was not a question

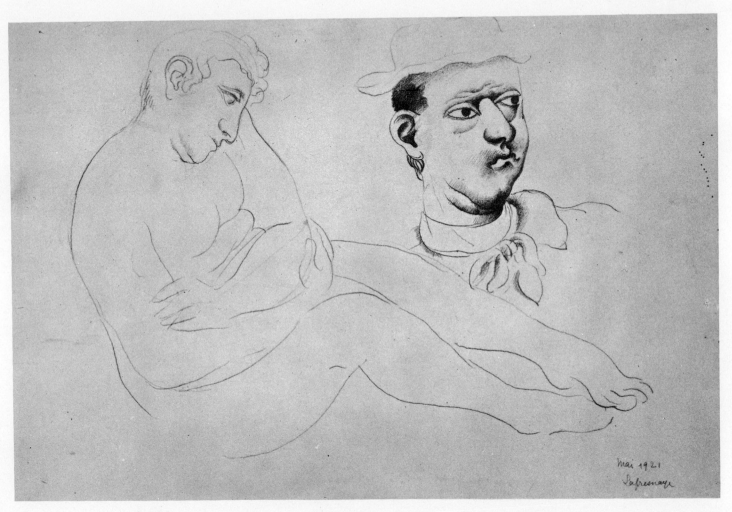

Figure 5

Roger de LA FRESNAYE • *Femme nue et tête de paysan, 1921* • pencil on buff paper, 10⅛ x 15⅛ inches • New Haven
Yale University Art Gallery, Bruce B. Dayton Fund

of reproducing reality through real elements but of creating reality with real elements.

Also outside the mainstream of Expressionism were a diverse number of important artists who with humanistic realism worked in the more traditional style in the early decades of the twentieth century. Perhaps the most compassionate single personality was Kaethe Kollwitz who through her drawings expressed the social conflicts and haunting tragedies of the time with extraordinary perception and sympathy. In the broad symbolism of her work she gives to specific events universal meaning. With a few strong lines and dark masses she transmits a sense of humility and a majestic acceptance of life.

In the pulsating drawings of Ernst Barlach are found a tenuous link between a baroque romanticism and the brooding conflicts of twentieth-century Expressionism. His work, like that of Kaethe Kollwitz, concerns itself with the vast world of people and their ultimate fate. Oskar Kokoschka, although born in Austria, spent most of his life in Berlin and Dresden—and in London during World War II. His influence on modern art is not to be forgotten. The nervous brilliance of his draughtsmanship is well demonstrated in the long series of searching portraits of his contemporaries. His imaginative projection of the personalities of his subjects bespeaks an artist of astute psychological insight.

Paul Klee ranks among the few truly perceptive innovators of the modern era. In his disarmingly modest water colors and drawings, he achieved a clear synthesis of line, color and form which penetrates to the very fountainhead of inspiration. His sheer mastery of his medium is exemplified in his visionary transformation of reality into the heightened realm of fantasy. It leads the spectator into a world unique in its strange but revealing reveries.

Surrealism in its more highly developed aspects was the logical step from the earlier Dada cult of the absurd. In its literary and visual aspects it was an attempt to work out techniques and methods of tapping the store of images hidden beyond the conscious image. Its basic purpose was to find such images

through a penetration of the irrational through hypnotic states, hallucination, dreams, intoxication and pursuit of the supernatural. Among the artists who from time to time seriously sought fantastic or irrational images were Max Ernst, Duchamp, Arp, Masson, Picasso, Man Ray, Tanguy, Giacometti, Chagall, Miró and Dali. Their drawings of dream landscapes and fantastic symbols are often highly romantic in character and are executed with knowing skill. Through ambiguities and strange overtones many meanings may be found in what Max Ernst once described as "fortuitous meeting of distant realities." In her discussion of the surrealist object, Anna Balakian observes: "The apocryphal aspect of the universe in a Tanguy painting is more relevant to our time than the angels of Raphael, for it conveys in succinct eloquence modern man's current obsession: to extricate himself from the established order of earthbound measurements and to discover a new relationship between his mortal self and the immortal reality with which he considers himself in daily contact."[10]

Joan Miró was among a goodly company of artists who, in the early decades of the twentieth century, counted Paris as a second home. In spite of the underlying gaiety and the rich spontaneity of his draughtsmanship Miró was never wholly involved in the surrealist probings of the unconscious. None the less, despite its underlying gaiety and spontaneity his work is essentially a surrealist expression. Influenced by Paul Klee, whom he discovered in 1924, Miró's drawings and paintings represent a continuous metamorphosis of the human figure into a highly-stylized idiom. Herbert Read has observed that Miró and Klee have a special authority because they alone have been able to approach the world of things with a vision that is at once innocent and profoundly revealing.[11]

A highly important effort in the trend toward abstraction in the arts was the founding of the Bauhaus in 1919 under the inspiring direction of Walter Gropius. Set up in the city of Weimar in Germany, its avowed purpose was to re-unite the artist and the craftsman into a strong twentieth-century creative

10. Balakian, Anna. *Surrealism: The Road to the Absolute.* New York, 1959, p. 161.
11. Read, Herbert. Review of *Joan Miró* by Jacques Dupin, New York, 1962, in *The Reporter,* June 6, 1963, p. 40.

force through the formulation of basic laws of form in all the arts. Among those dedicated artists who worked toward the re-alignment of the arts and crafts were Kandinsky, Feininger, Klee and Moholy-Nagy. Gropius gathered around him other important artists including Schwitters, Lissitsky, Jawlensky, Schlemmer, Mondrian, Macke and Albers. Their underlying influences came directly from Cubism, Der Blaue Reiter, Futurism and Constructivism. A well-knit professional group, the impact of their ideas and carefully formulated principles was international in its scope and continues to inspire architects, painters, sculptors and craftsmen. This dynamic school after several years in Weimar moved its studios and shops first to Dessau and thence to Berlin. In 1933, after intense political pressure made further experimental and creative work impossible, this splendid venture was terminated. Gropius, Feininger, Moholy-Nagy and Albers left Germany for the United States. Klee returned to Switzerland; some moved away to smaller towns in Germany, and still others left for bordering countries.

At the time of the Bauhaus in Europe a more agressive and turbulent development in the arts was taking place in Mexico. Young, impatient and revolutionary artists set out to re-vitalize the whole of Mexican painting. Fostered by a generally receptive government the immensity of this project and the driving zeal of the artists revealed itself in giant frescos and the attendant large-scale paintings and graphic studies. A measure of this effort is noted in the well-known work of Rivera, Orozco and Siqueiros.

Premonition of the coming holocaust was only too evident in Germany. In the early curtailment of the arts through political pressures, many of the younger artists left Spain, Germany, Switzerland, Italy and Eastern Europe to settle in Paris. This proved to be an uneasy haven and by 1939 the exodus was formidable. Some came to the United States, others went to England, Mexico and South America. The older, more firmly-established artists for the most part remained in their studios. In Germany they were often deprived of materials and were forced into seclusion and inactivity. In other lands the

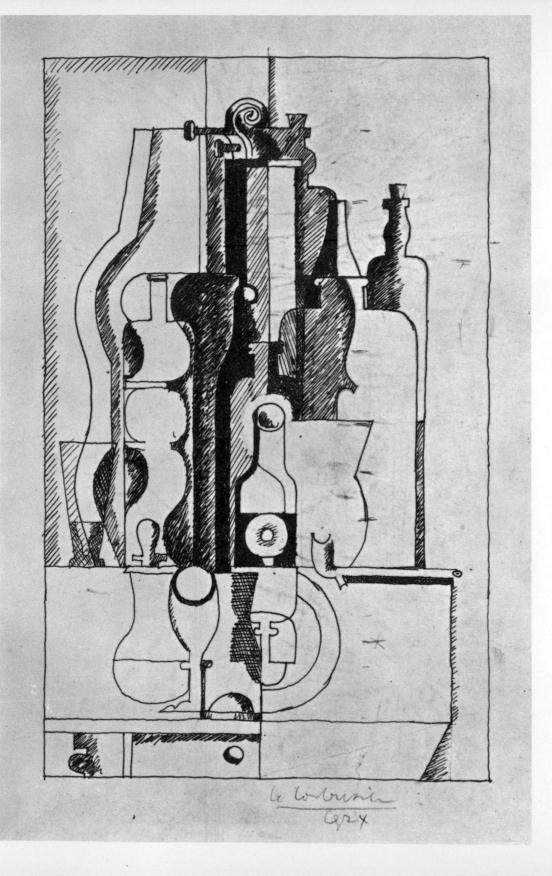

Le Corbusier
1921

29

ruthless progression of events left little time or inclination for serious creative work.

The efflorescence of twentieth-century art in Europe—so luminous and revealing in the earlier decades of the century—died down to a disquieting stillness. Nevertheless, it is to the eternal credit of the artist of every age that although free expression in the arts may be arrested or politically limited, he clings to the vast—and to him—rewarding world of visual ideas and images. Whether these are inspiring or disillusioning, they remain his declared way of life.

UNA E. JOHNSON

Plates

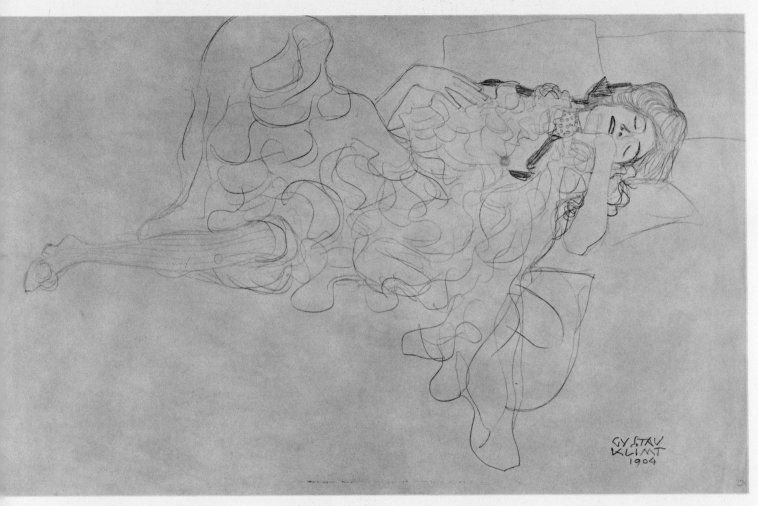

Plate 1

Gustav KLIMT · *Woman Lying Down, 1904* · pencil, 13¾ x 21⅝ inches · Stuttgart, Staatsgalerie

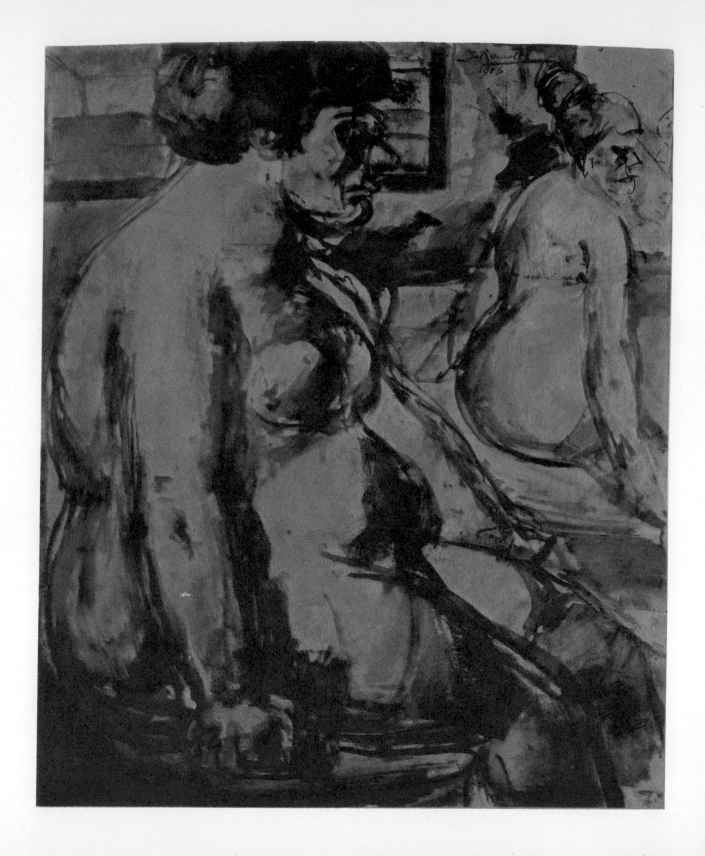

34

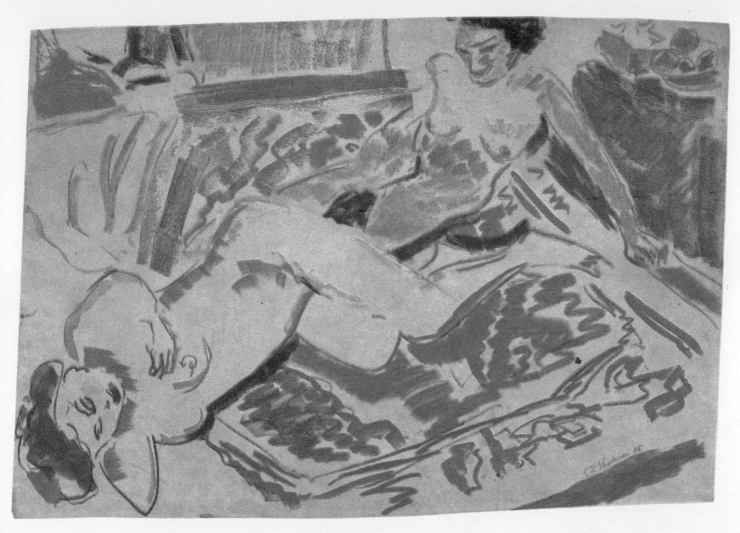

Plate 3
Ernst Ludwig KIRCHNER • *Two Nudes, 1905* • colored chalks, 25¼ x 35⅜ inches • The Art Institute of Chicago
The Albert Kunstadter Family Fund

Plate 2
Georges ROUAULT • *Two Prostitutes, 1906* • water color, 26½ x 21¾ inches • New York, Dr. and Mrs. Harry Bakwin

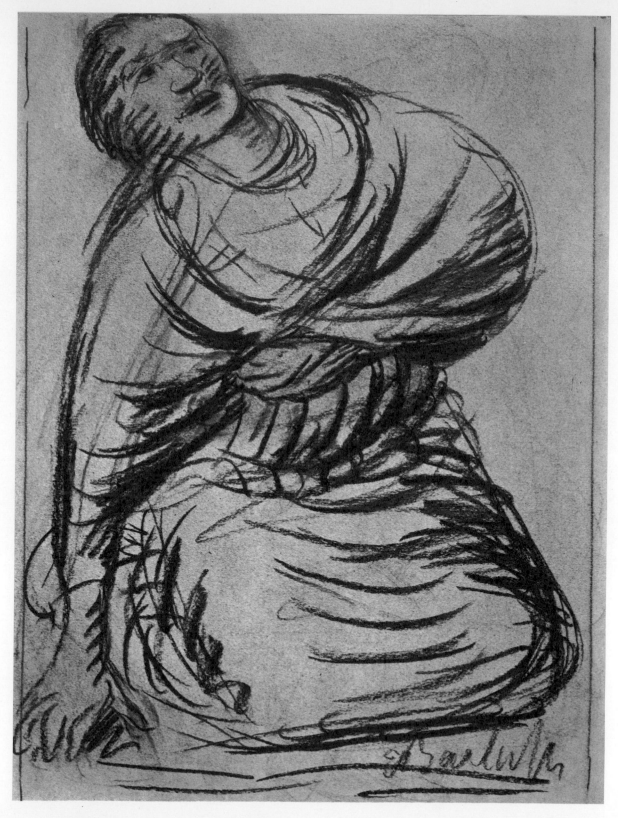

Plate 4
Ernst BARLACH
Kneeling Beggar Woman
1906
black chalk
13⅝ x 10³⁄₁₆ inches
Vienna, Albertina Gallery

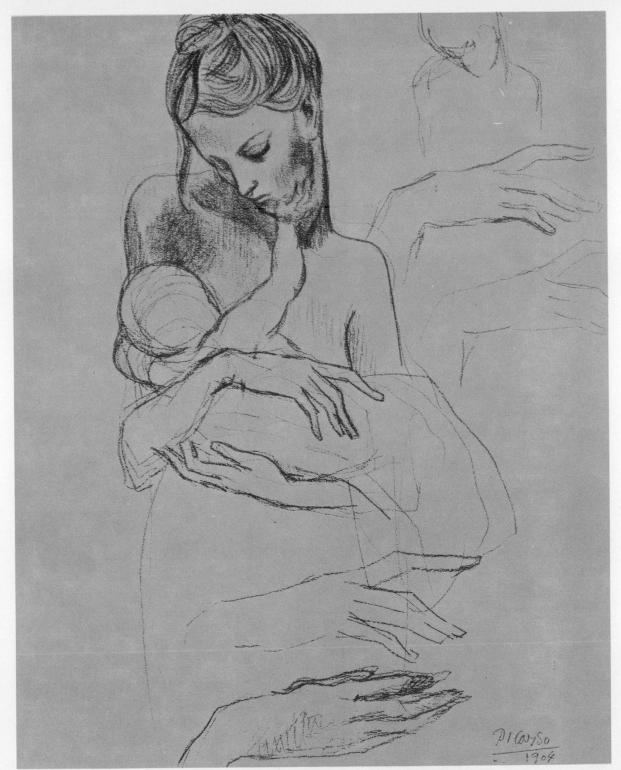

Plate 5
Pablo PICASSO
*Mother and Child and
Four Studies of a
Right Hand*, 1904
black crayon on cream
paper, 10¼ x 13 inches
Cambridge, Mass.
Harvard University
Fogg Art Museum
Meta and Paul J. Sachs
Collection

37

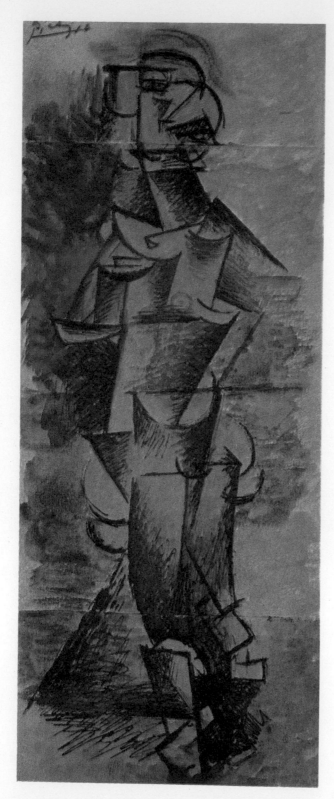

Plate 6
Pablo PICASSO
Standing Nude, 1910
ink and water color, 12 x 4¾ inches
Private Collection

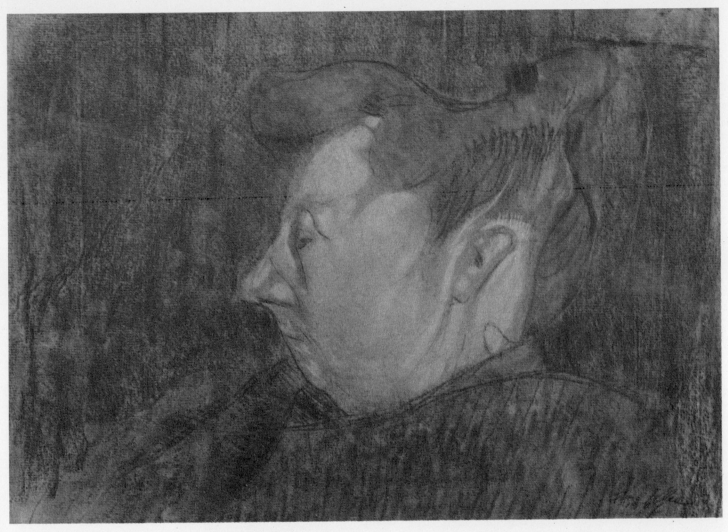

Plate 7
Paul KLEE • *Portrait, 1907* • charcoal, water-color wash, 9½ x 13 inches • The Brooklyn Museum

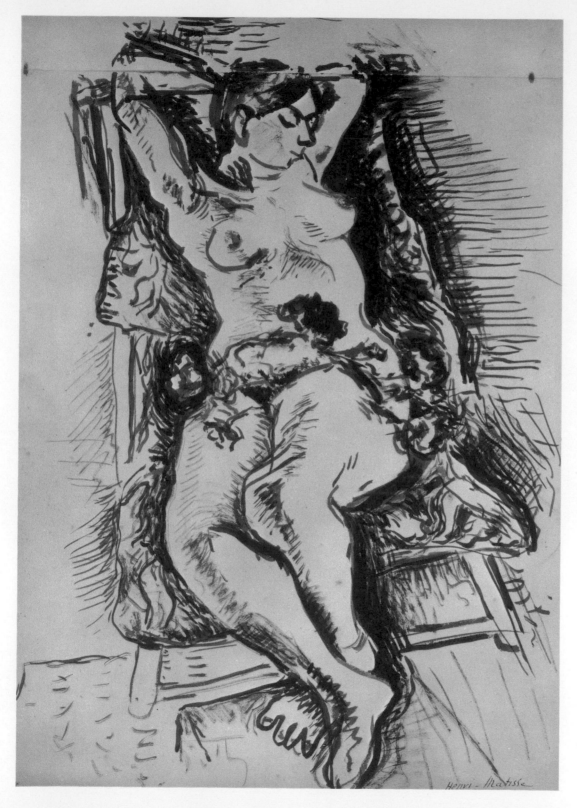

Plate 8
Henri MATISSE
Nude in Armchair, ca. 1906
India ink with brush
25⅞ x 18⅜ inches
The Art Institute of Chicago
Gift of Mrs. Potter Palmer

Henri - Matisse

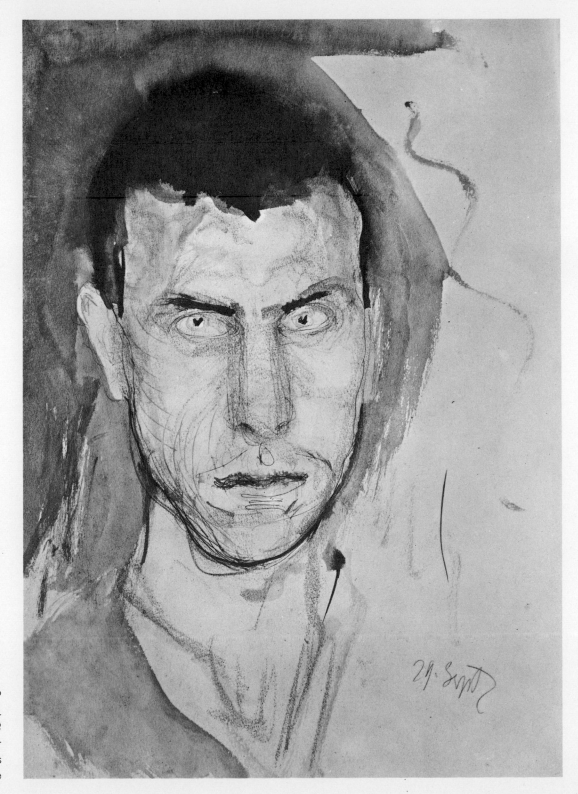

Plate 9
Richard GERSTL
Self-Portrait, probably 1908
wash on white paper
15¾ x 11¾ inches
New York, Galerie St. Étienne

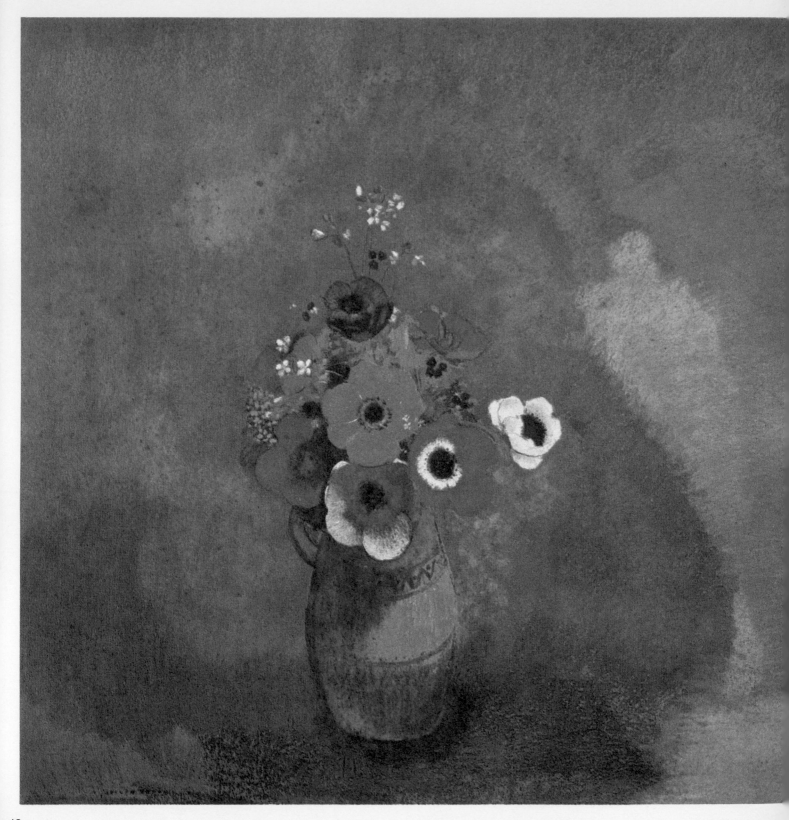

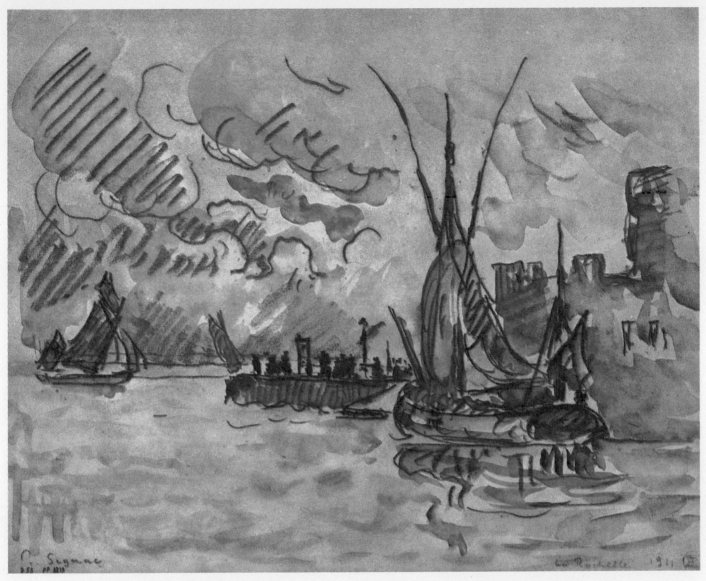

Plate 11
Paul SIGNAC · *La Rochelle, 1911* · water color and black crayon, 9 1/16 x 11 1/8 inches · Paris, Petit Palais

ate 10
Odilon REDON · *Bouquet of Anemones, ca. 1910* · pastel, 25 9/16 x 24 13/16 inches · Paris, Petit Palais

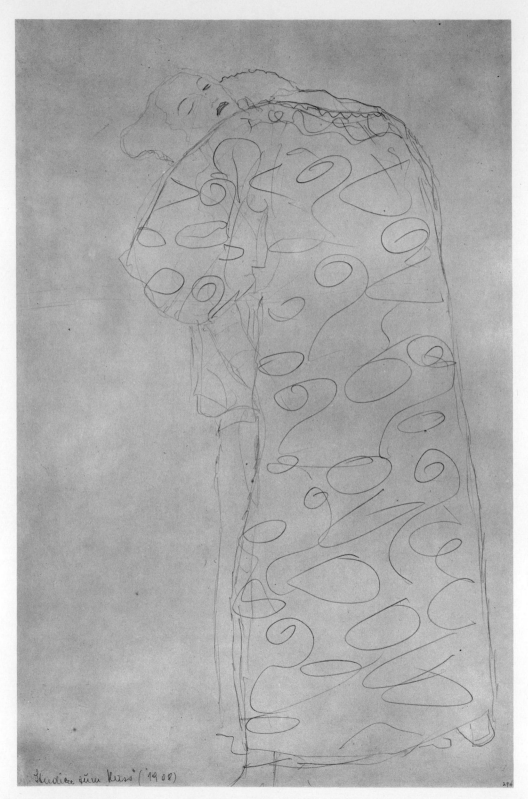

Studien zum Kuss (1908)

294

Plate 12
Gustav KLIMT
The Kiss, 1908 (Study for the painting
"The Fulfillment")
pencil on white paper
22½ x 14½ inches
New York
Dr. and Mrs. Louis R. Wasserman

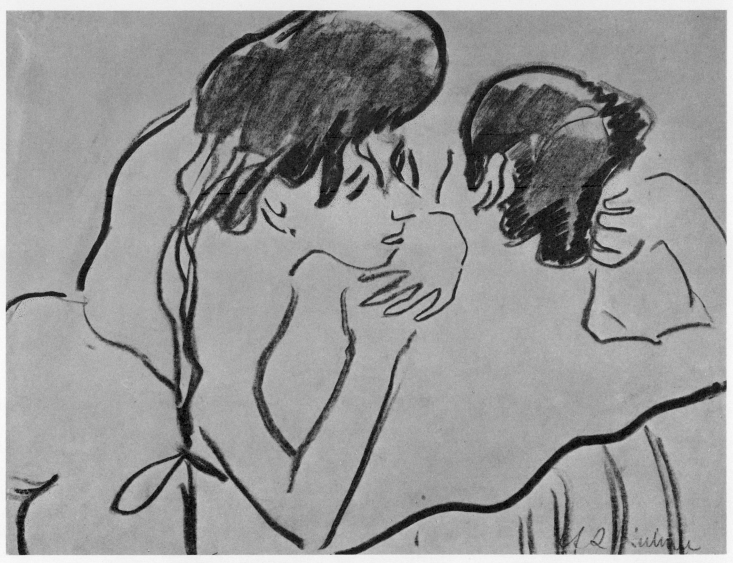

Plate 13
Ernst Ludwig KIRCHNER • *Nudes, 1905-10* • charcoal, 13½ x 17½ inches • New York, The Solomon R. Guggenheim Museum

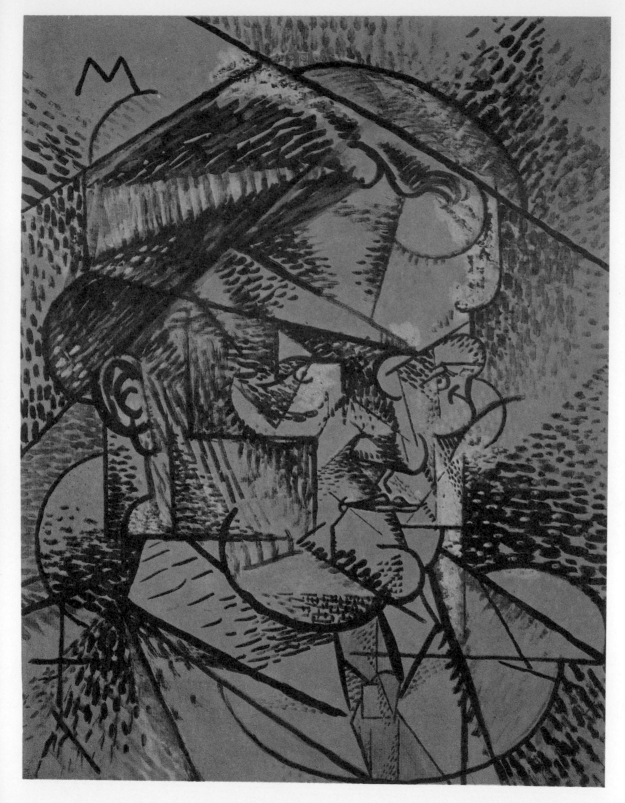

Plate 14
Louis MARCOUSSIS
Portrait of Édouard Gazanion
ca. 1912
water color, India ink and
gouache on buff paper
25 x 19¼ inches
Detroit, Mr. Bernard F. Walker

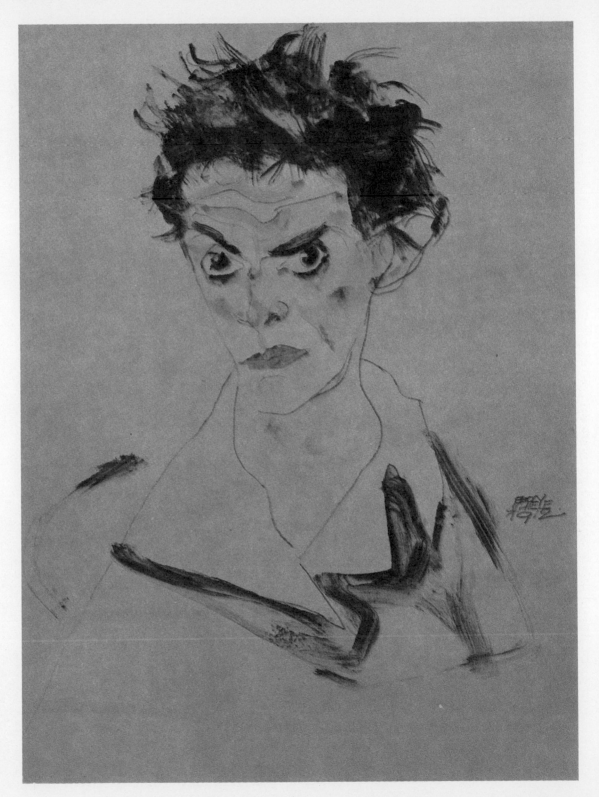

Plate 15
Egon SCHIELE
Self-Portrait, 1912
black crayon and water color
on buff paper
12¼ x 9⅜ inches (sight)
New York, Galerie St. Étienne

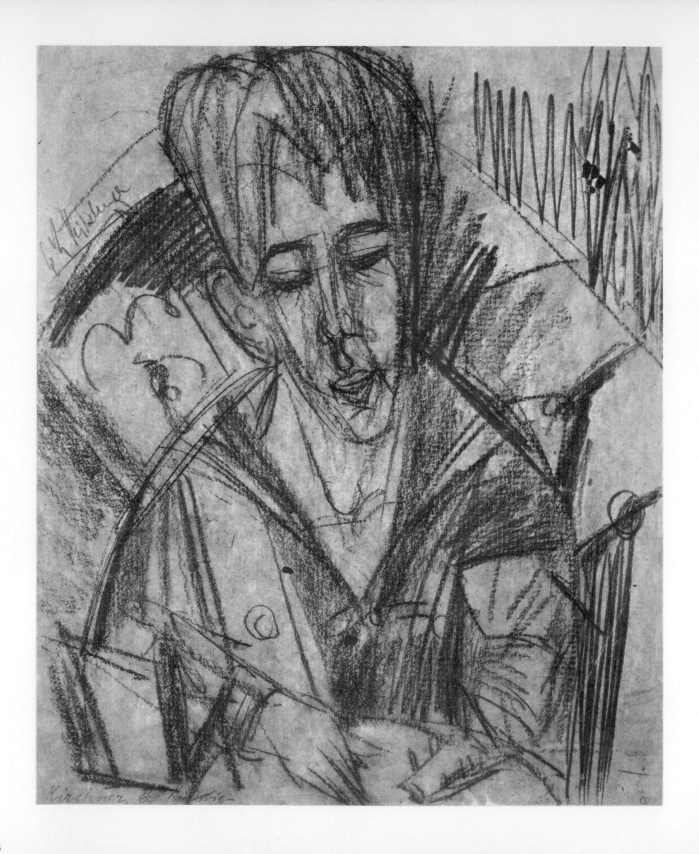

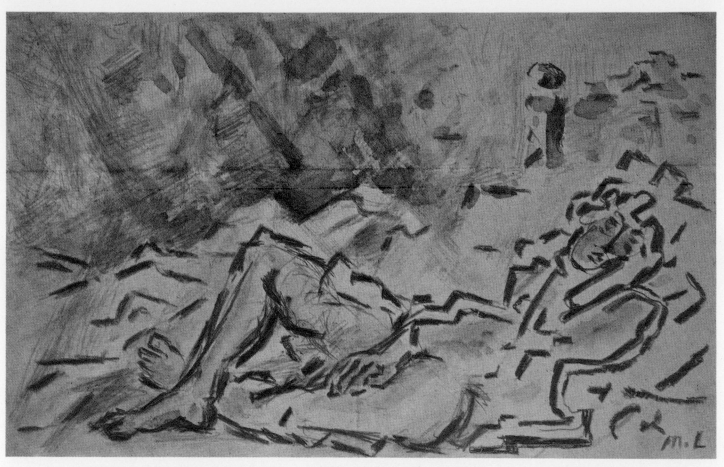

Plate 17
Michael LARIONOV • *Reclining Female, ca. 1909* • pencil and wash on tan paper, 6¾ x 11 inches (sight) • Private Collection

Plate 16
Ernst Ludwig KIRCHNER • *Portrait of a Boy, 1910* (Study for the painting, "The Sick Boy") • charcoal, 23¼ x 19⅝ inches
 Hamburg, Kunsthalle

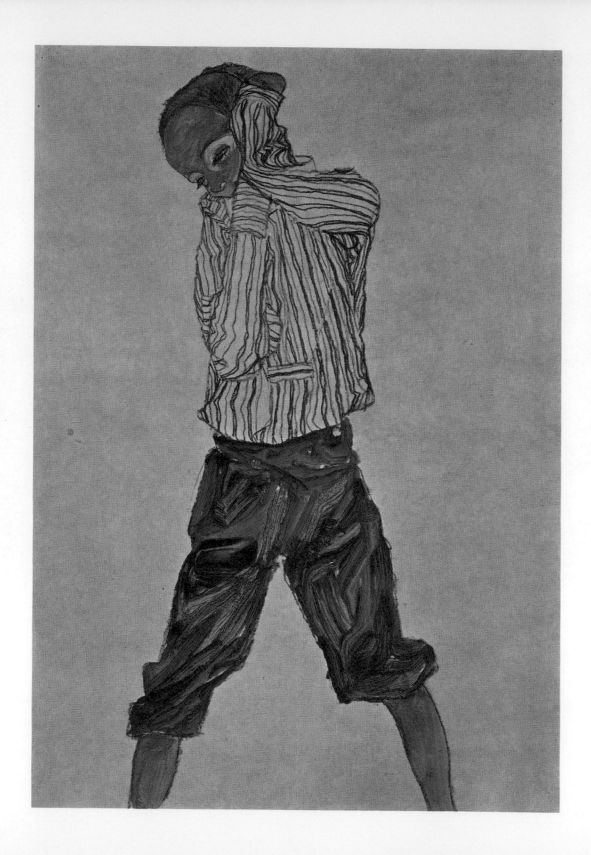

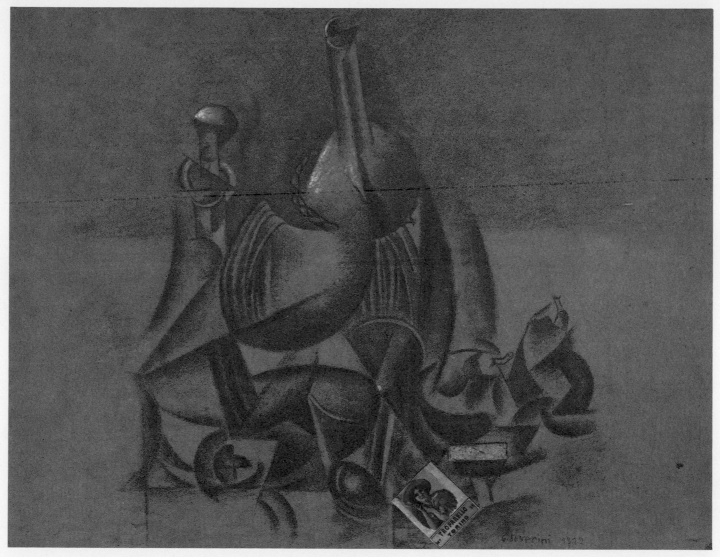

Plate 19
Gino SEVERINI • *Still Life with Wine Bottle, 1912* • black chalk on brown paper, with a small collage, 19 x 24⅜ inches • St. Louis
Mr. and Mrs. Joseph L. Tucker

ate 18
gon SCHIELE • *Boy in a Striped Shirt, n.d.* • black chalk and water color, 17¹³⁄₁₆ x 12½ inches • Vienna, Private Collection

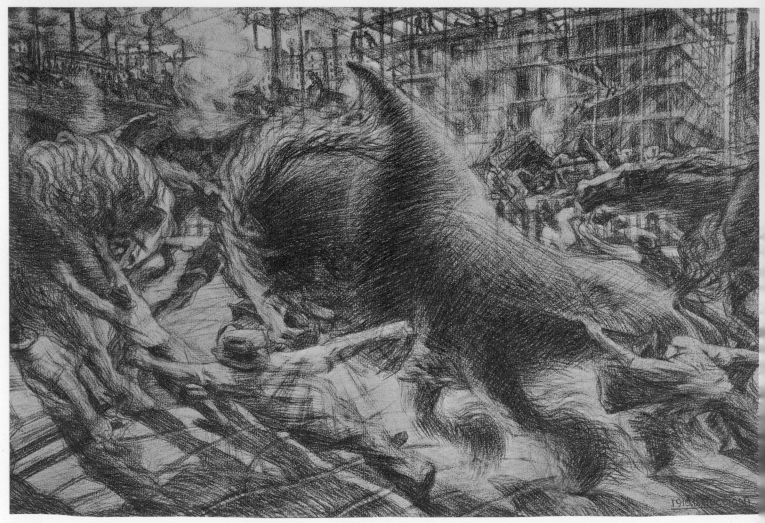

Plate 20
Umberto BOCCIONI • *The City Rises, 1910* • crayon and black chalk on white paper, 23⅛ x 34⅛ inches • New York
The Museum of Modern Art, Acquired through the Mrs. Simon Guggenheim Fund

Plate 21
Albert MARQUET • *Nude, 1911-12* • India ink on white paper, 11⅝ x 8⁵⁄₁₆ inches • Ottawa, The National Gallery of Canada

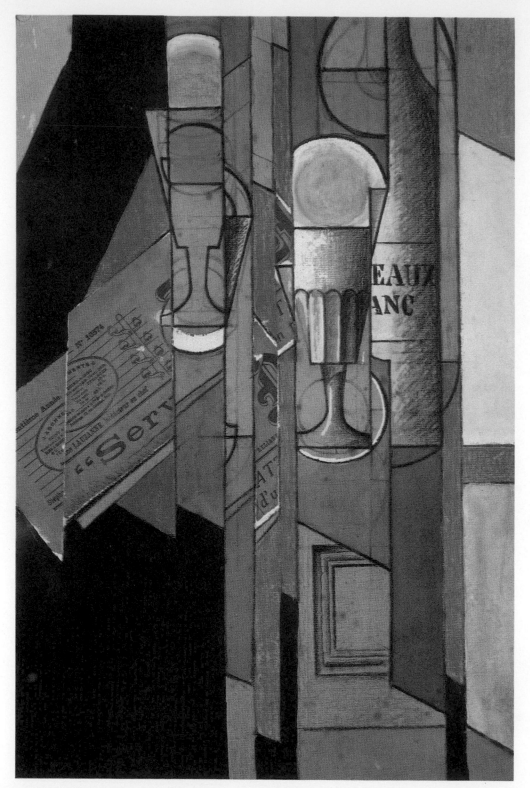

Plate 22
Juan GRIS
Verres, journal et bouteille de vin, 1913
collage and pastel on paper
17½ x 11½ inches
New York
Mr. and Mrs. Armand Bartos

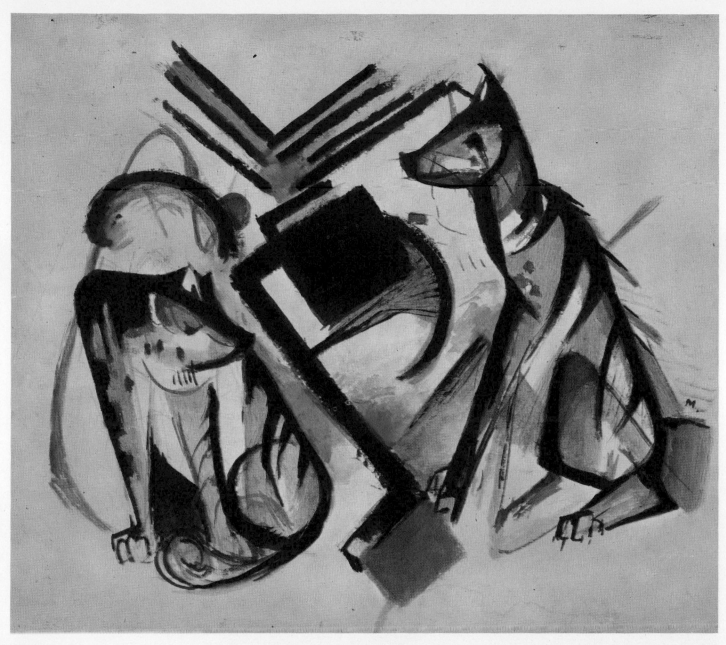

Plate 23
Franz MARC · *Black Wolves, 1913* · water color and ink with pencil, 15¼ x 17¾ inches New York, The Solomon R. Guggenheim Museum

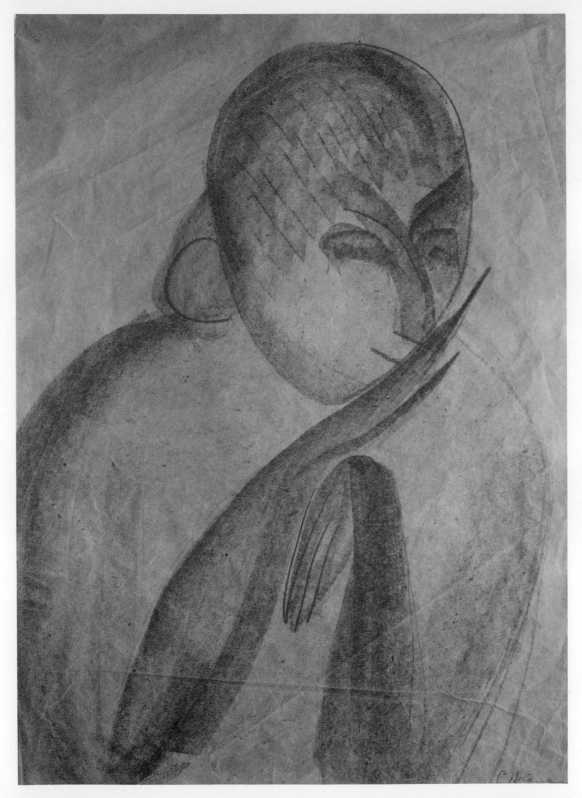

Plate 24
Constantin BRANCUSI
Mademoiselle Pogany, 1912
pencil on brown paper
21½ x 16½ inches (sight)
The Philadelphia Museum of Art
A. E. Gallatin Collection

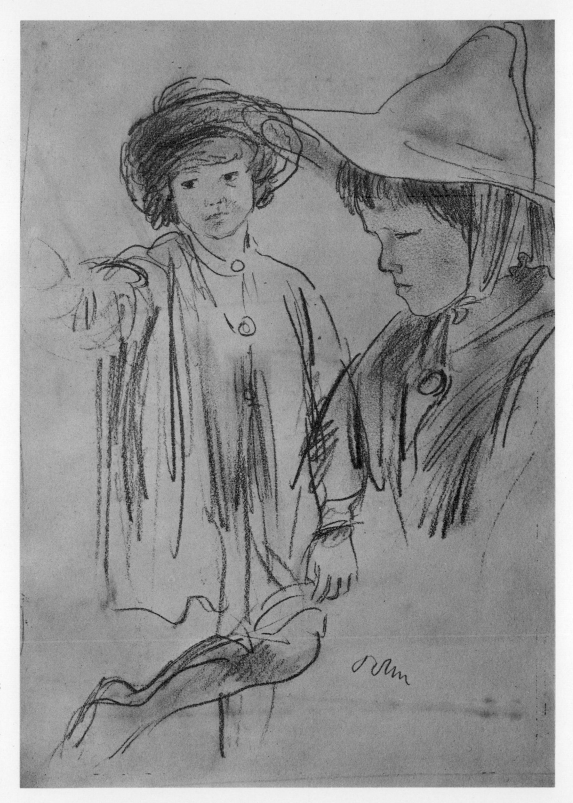

Plate 25
Augustus Edwin JOHN
Two Children, probably 1911-12
charcoal on white laid paper
13½ x 9⅝ inches
New York
Mr. and Mrs. Daniel H. Silberberg

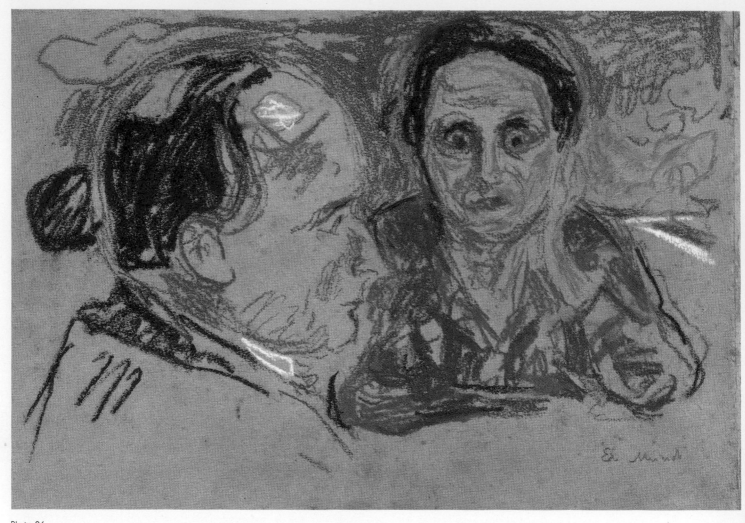

Plate 26

Edvard MUNCH • *Portrait of Curt and Elsa Glaser, ca. 1913 (?)* • pastel, 9¼ x 13¼ inches • Munich, Mr. and Mrs. Walter Bareiss

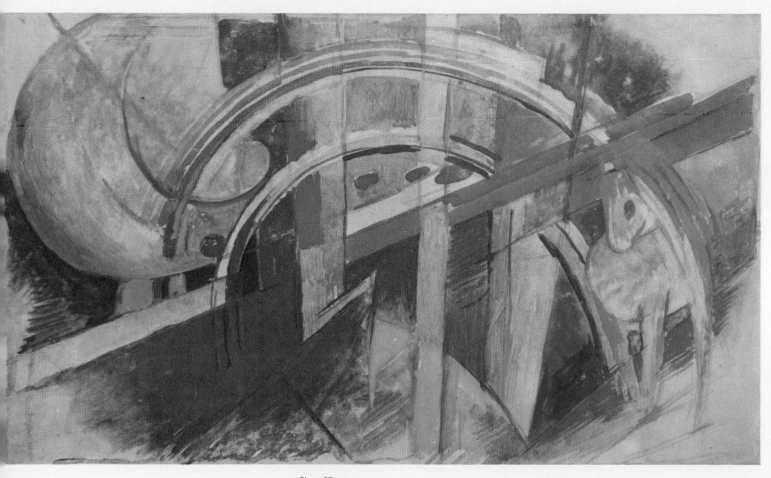

Plate 27

Franz MARC • *Blue Horse in a Landscape, 1913* • gouache, 6 x 10 inches • Private Collection

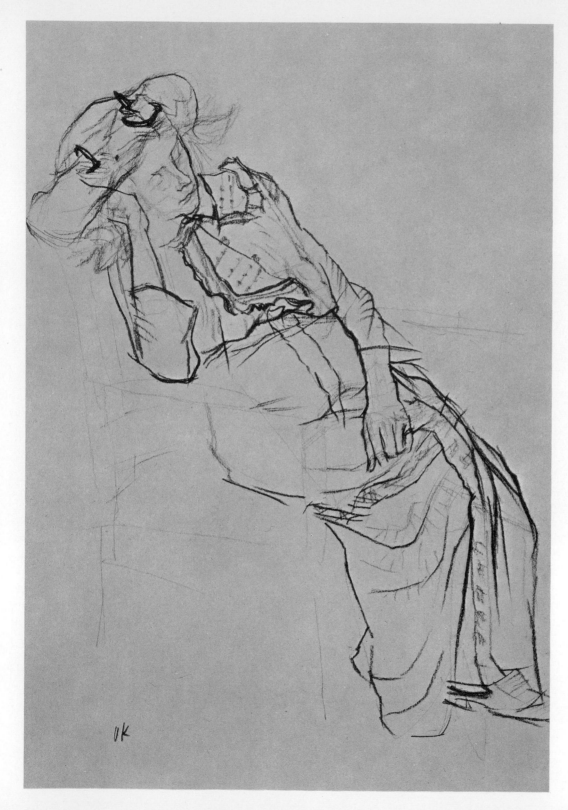

Plate 28

Oskar KOKOSCHKA
*The Artist's Mother Relaxing
in an Armchair, ca. 1912*
black chalk, 15¾ x 11 inches
Vienna, Albertina Gallery

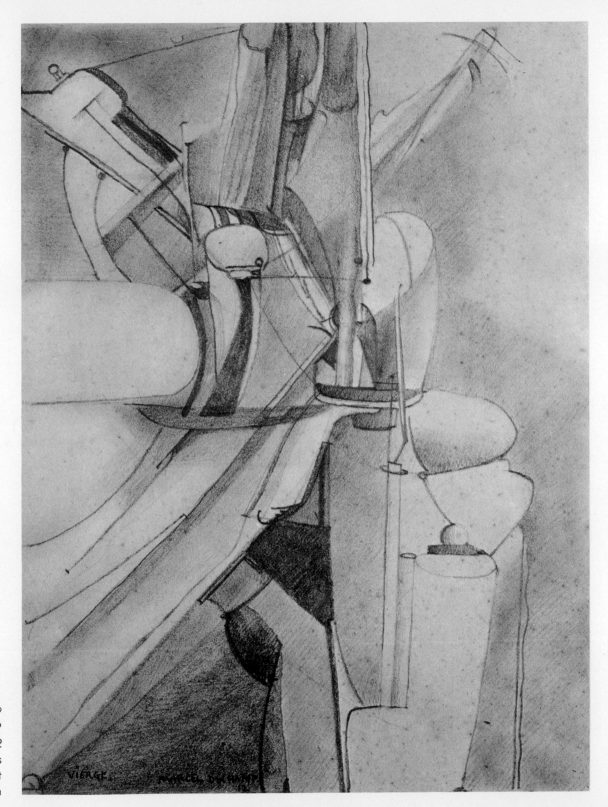

Plate 29
Marcel DUCHAMP
Virgin, No. 1, 1912
pencil, 12½ x 9 inches
The Philadelphia Museum of Art
A. E. Gallatin Collection

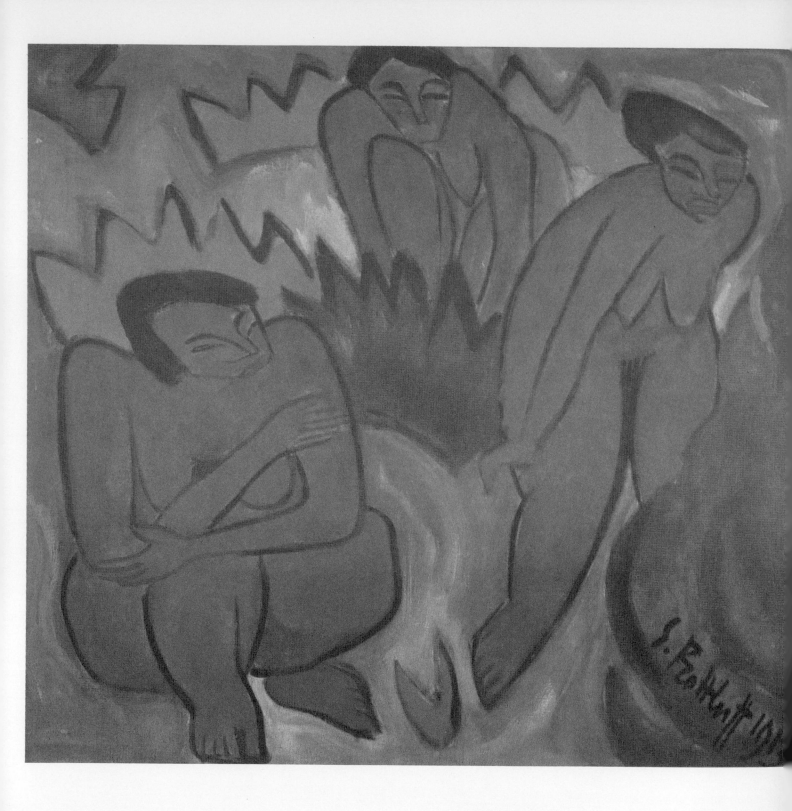

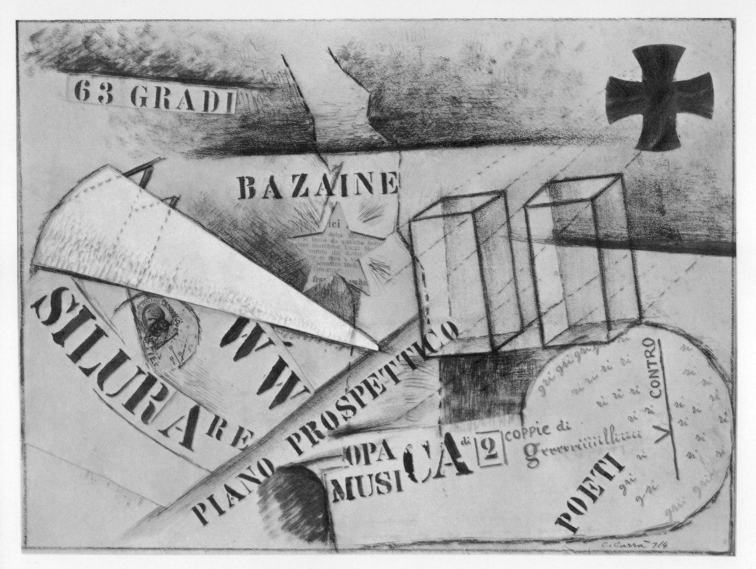

Plate 31
Carlo CARRÀ · *Joffre's Angle of Penetration on the Marne against Two German Cubes, 1914*
pasted papers, newsprint, postage stamp, pencil, Conté crayon, ink, ink wash and white gouache on white paper, 10 x 13½ inches
Birmingham, Michigan, Mr. and Mrs. Harry Lewis Winston

Plate 30
Karl SCHMIDT-ROTTLUFF · *Three Nudes, 1913* · water color and gouache, 17½ x 21¾ inches · Berlin, 20th Century Gallery

Merkel 12

64

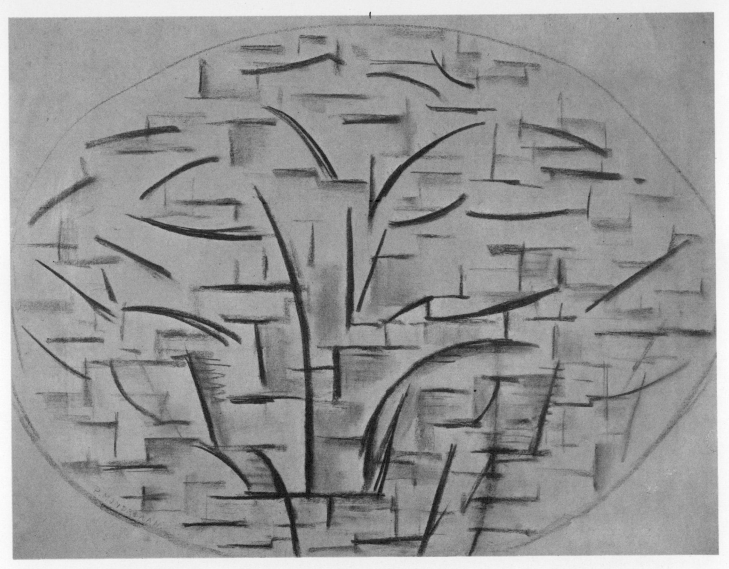

Plate 33
Piet MONDRIAN · *Apple Tree, 1912 (?)* · charcoal on gray paper, 18½ x 24½ inches (sight) · Wellesley, Mass.
Mr. and Mrs. John McAndrew

Plate 32
Erich HECKEL · *Head of a Girl, 1912* · pencil on white paper, 17⅝ x 13¼ inches · Lincoln, University of Nebraska
F. M. Hall Collection

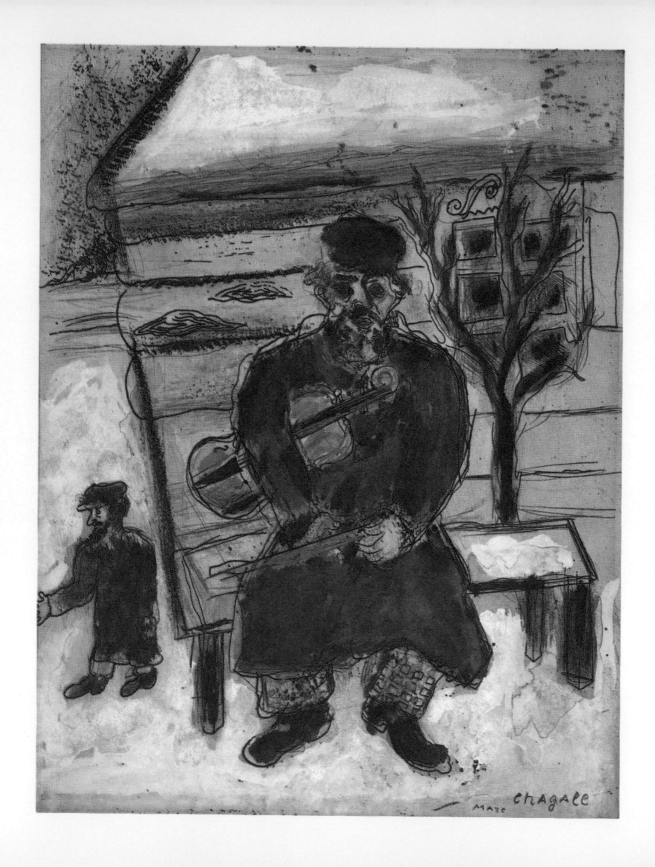

66

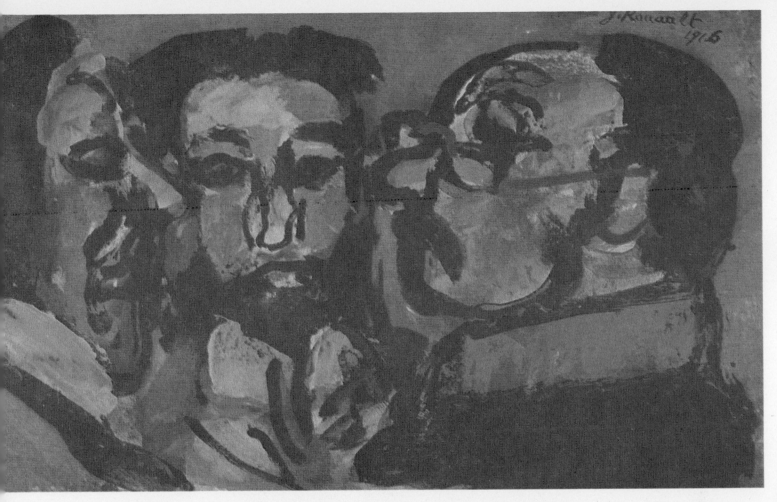

Plate 35
Georges ROUAULT · *Three Judges, 1916* · gouache, 7 x 11½ inches · The Philadelphia Museum of Art, The Hanley Collection

Plate 34
Marc CHAGALL · *Old Musician, after 1914* · gouache and ink, 10¾ x 8¼ inches (sight) · Minneapolis, Mr. and Mrs. Mark Graubard

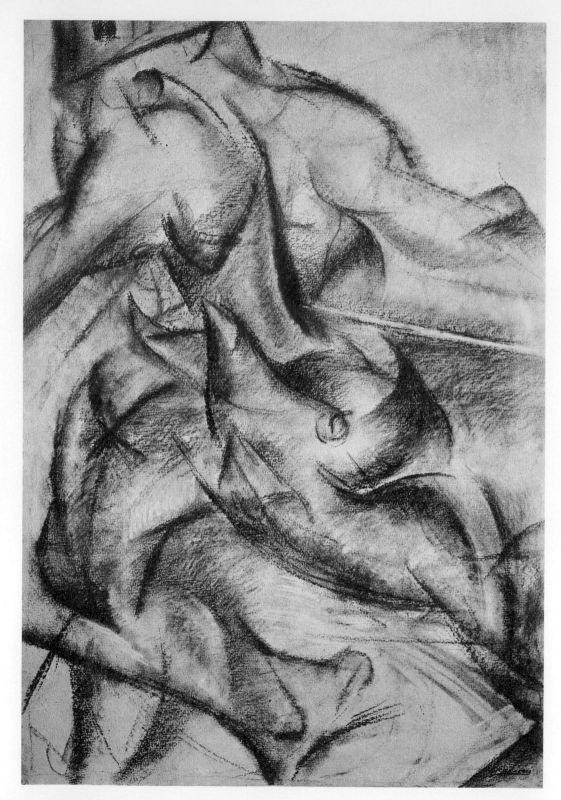

Plate 36
Umberto BOCCIONI
Muscular Dynamism, 1913
charcoal, 34 x 23¼ inches
New York
The Museum of Modern Art

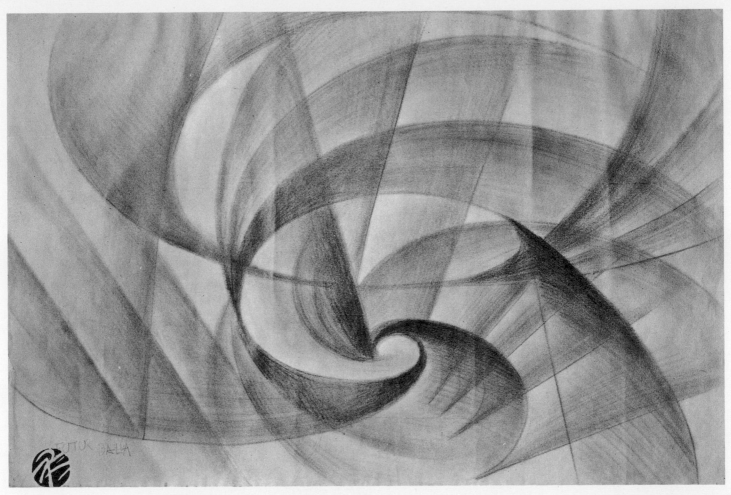

Plate 37
Giacomo BALLA · *Vortex-Line of Speed, 1913* · pencil on white paper, 16¾ x 25 inches · Birmingham, Michigan
Mr. and Mrs. Harry Lewis Winston

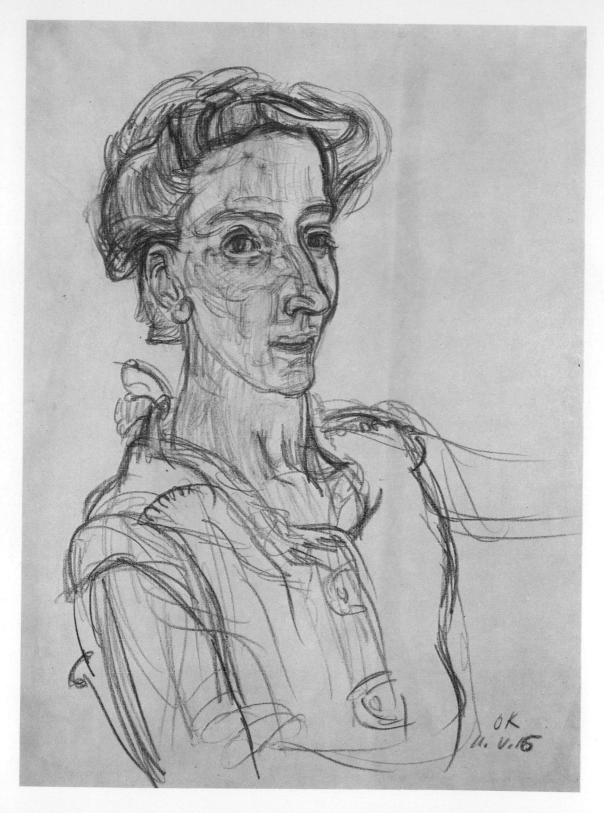

Plate 38
Oskar KOKOSCHKA
Portrait of a Lady, 1916
charcoal on
ivory-colored paper
23⅞ x 17½ inches
Cambridge, Mass.
Harvard University
Fogg Art Museum
Gift of James N. Rosenberg
in honor of Paul J. Sachs

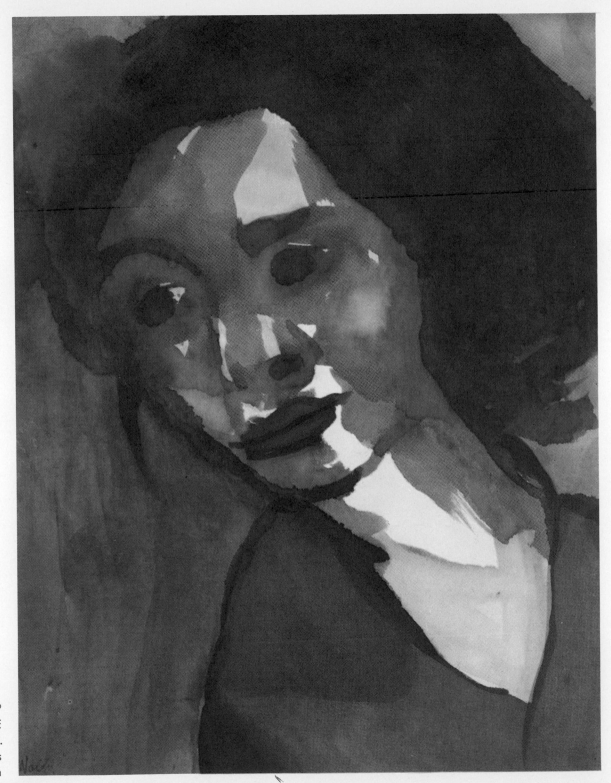

Plate 39
Emil NOLDE
Head of a Woman, n.d.
water color, 23 x 19 inches
Private Collection

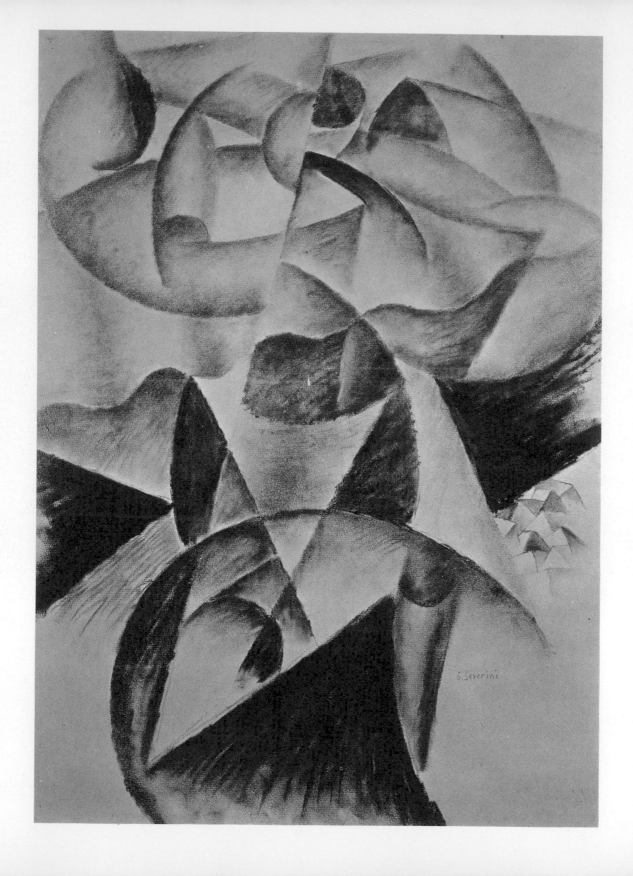

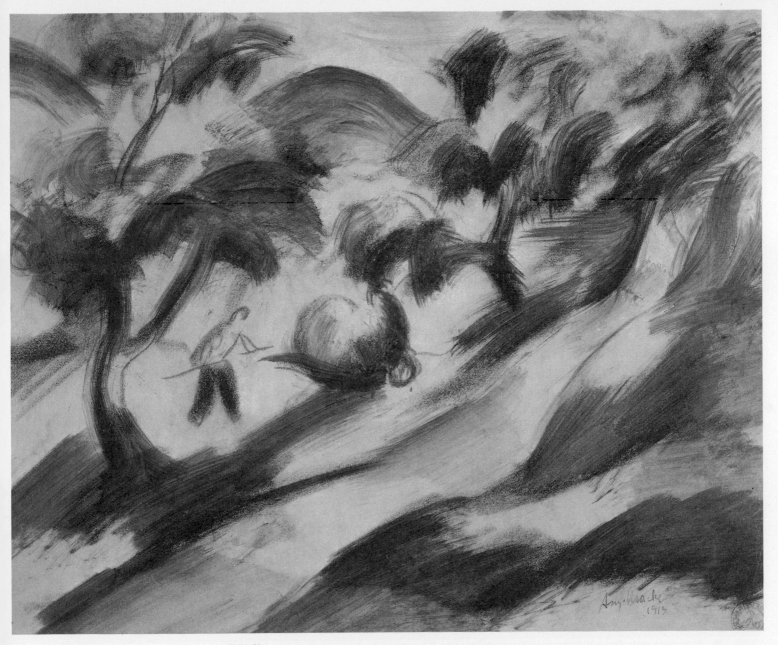

Plate 41
August MACKE · *Peasant Pitching Hay beneath Trees, 1913* · charcoal, brush in India ink, 9⅞ x 12¼ inches
Vienna, Albertina Gallery

Plate 40
Gino SEVERINI · *Study for "Dancer + Sea," 1913* · charcoal on white paper, · 27⅞ x 19⅞ inches (sight) · Birmingham, Michigan
Mr. and Mrs. Harry Lewis Winston

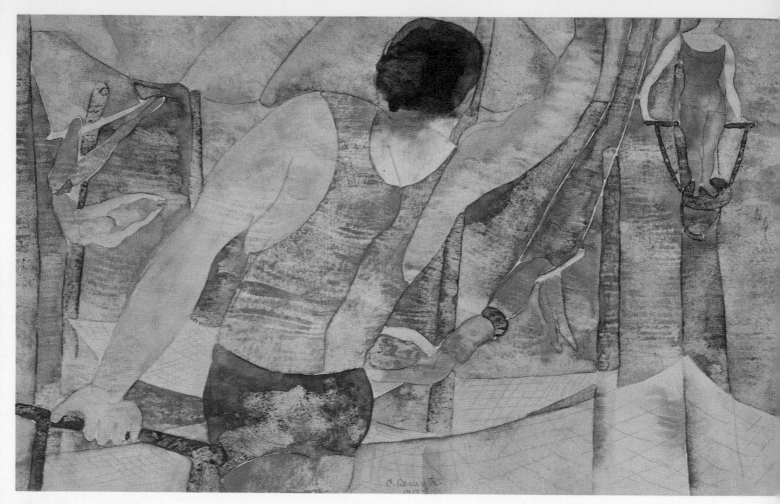

Plate 42
Charles DEMUTH • *Circus, 1917* • water color, 8 x 17 inches • New York, The Joseph H. Hirshhorn Collection

Plate 43
Amedeo MODIGLIANI • *Caryatid, 1914-15* • water color over pen and ink, pastel crayons, 11 ¼ x 9 ½ inches
Paris, Musée d'Art Moderne

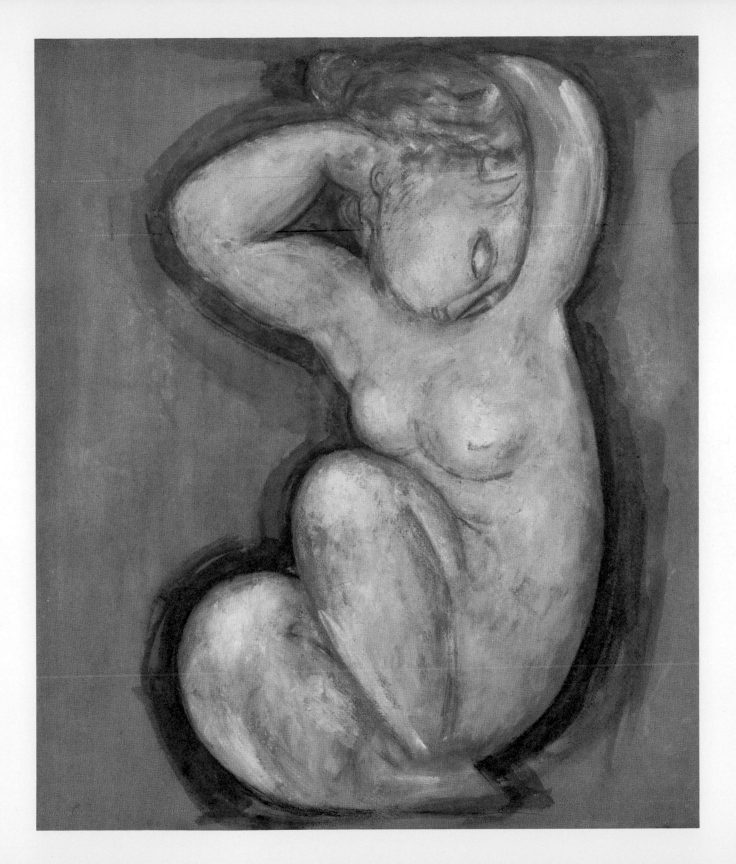

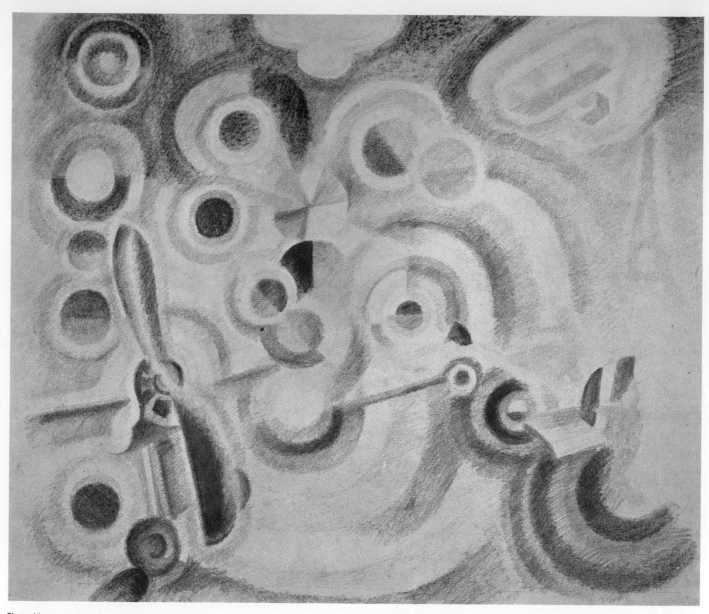

Plate 44
Robert DELAUNAY · *Homage to Blériot, 1914* · lithographic crayon on buff pebbled-textured paper, 19¾ x 23 inches
Private Collection

Plate 45
Albert GLEIZES · *Study 6 for "Portrait of an Army Doctor," 1915* · ink, 9⅝ x 8¾ inches · New York
The Solomon R. Guggenheim Museum

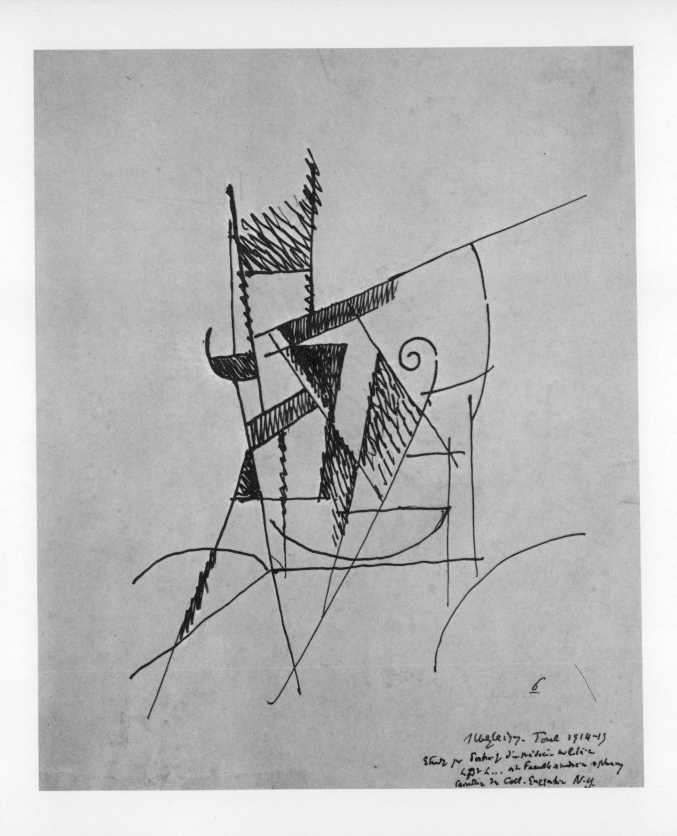

Albert Gleizes. Toul 1914-15

Étude pr. Portrait d'un médecin militaire
(Dr. L... de Faculté de médecine d'Nancy)
(carnets de Coll. Gallatin N.Y.)

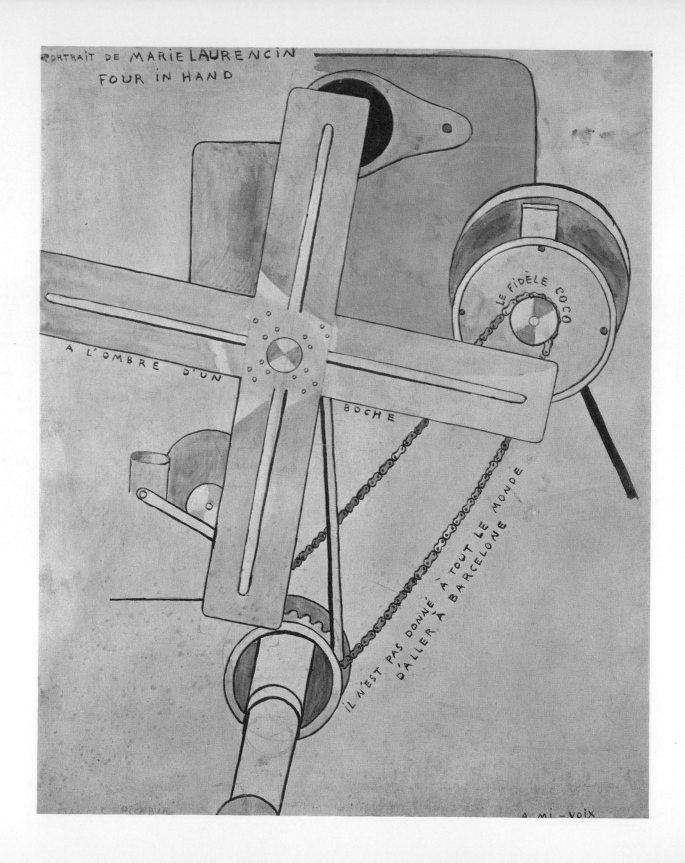

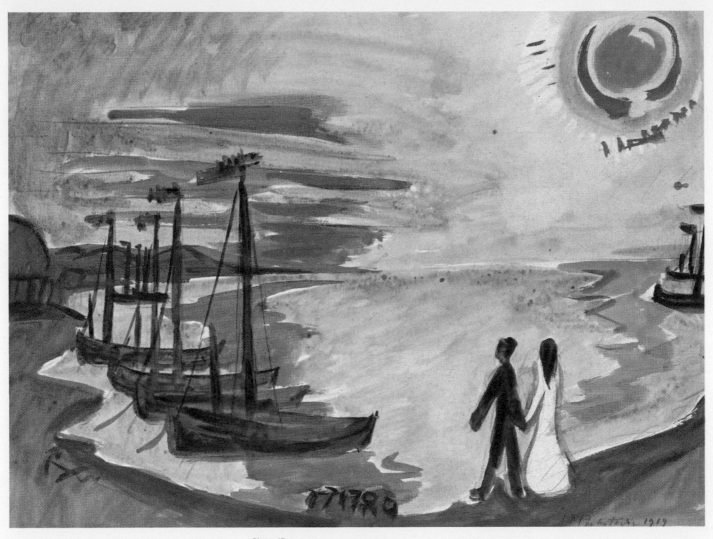

Plate 47
Max PECHSTEIN • *The Harbor, 1919* • water color, 11¾ x 13⅞ inches • Private Collection

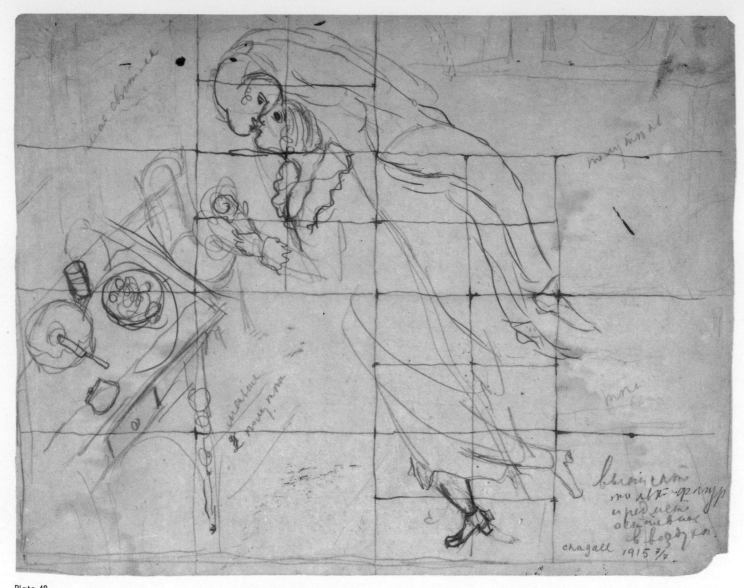

Plate 48
Marc CHAGALL · *Study for "The Birthday" ("The Anniversary")*, 1915 · pencil on buff paper, 9 x 11½ inches
New York, The Museum of Modern Art, Gift of the Artist

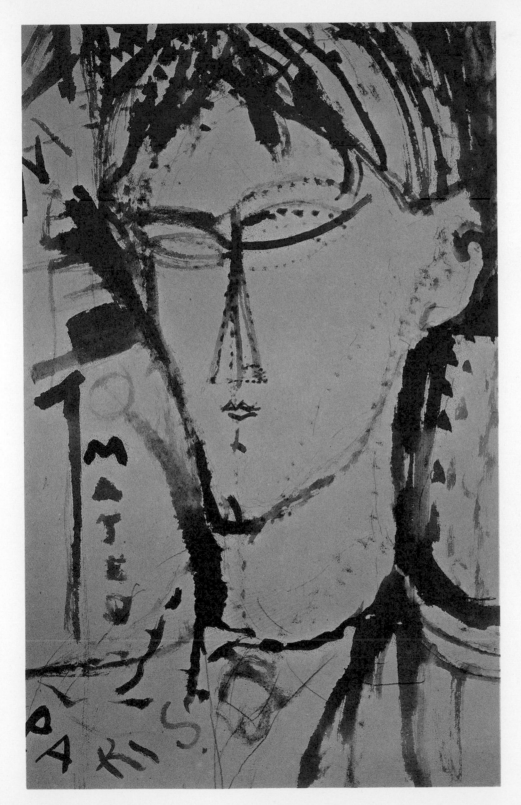

Plate 49
Amedeo MODIGLIANI
Portrait of Mateo Alegria, 1915
brush and ink wash on white paper
19½ x 12¾ inches
New York
Henry Pearlman Foundation

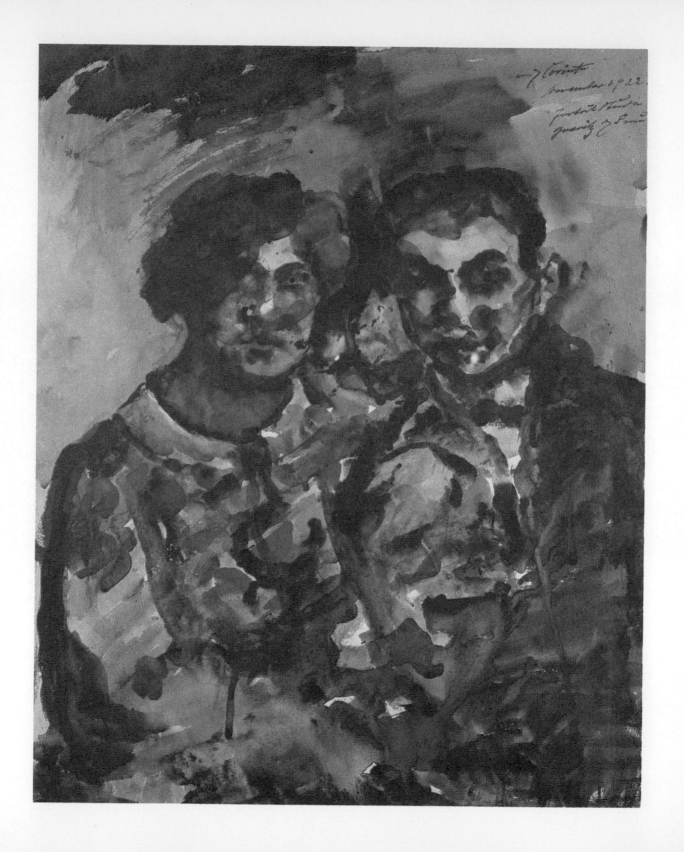

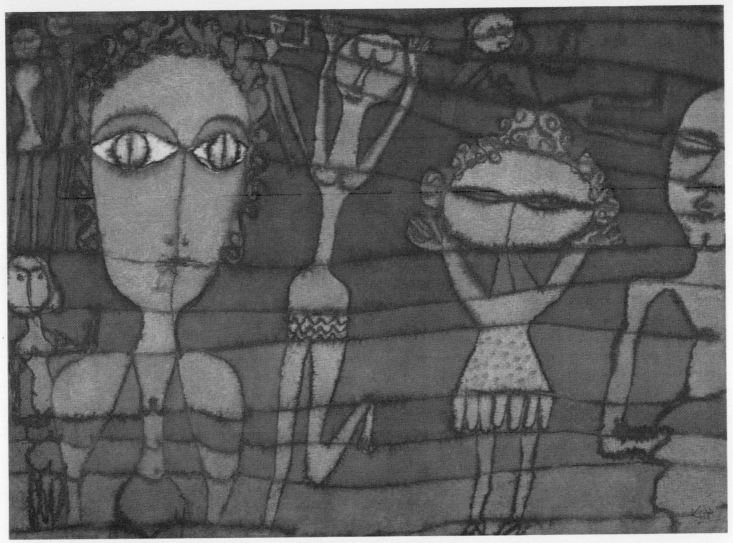

Plate 51
Paul KLEE · *In the Meadow, 1923* · water color, 8¾ x 11¾ inches · Private Collection

ate 50
ovis CORINTH · *Portrait of Goeritz and His Wife, 1922* · water color, 24 x 19⅛ inches · The Art Institute of Chicago
he Worcester Sketch Collection Fund

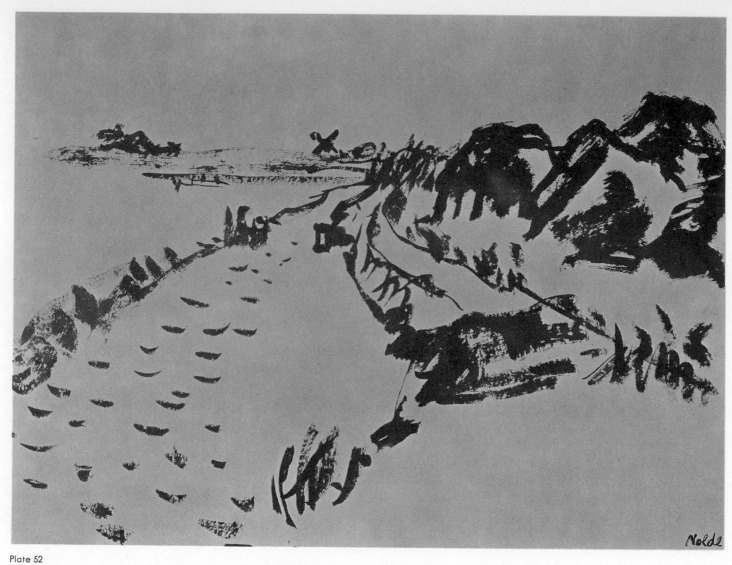

Plate 52

Emil NOLDE · *Landscape with Windmill, n.d.* · brush and black printer's ink on tan paper, 17½ x 23¼ inches (sight)
Great Neck, N.Y., Mrs. Heinz Schultz

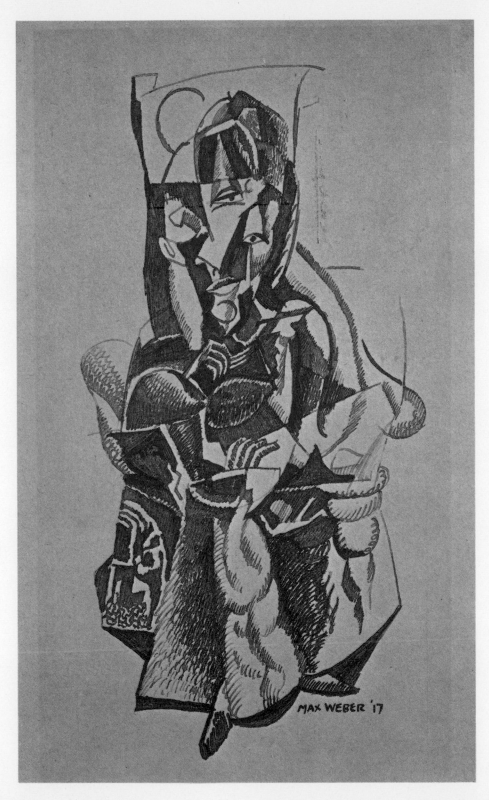

Plate 53
Max WEBER
Seated Figure, 1917
pen and black ink with black wash
on light brown paper
9⁹⁄₁₆ x 6¹⁄₁₆ inches
Cambridge, Mass.
Harvard University
Fogg Art Museum
Meta and Paul J. Sachs Collection

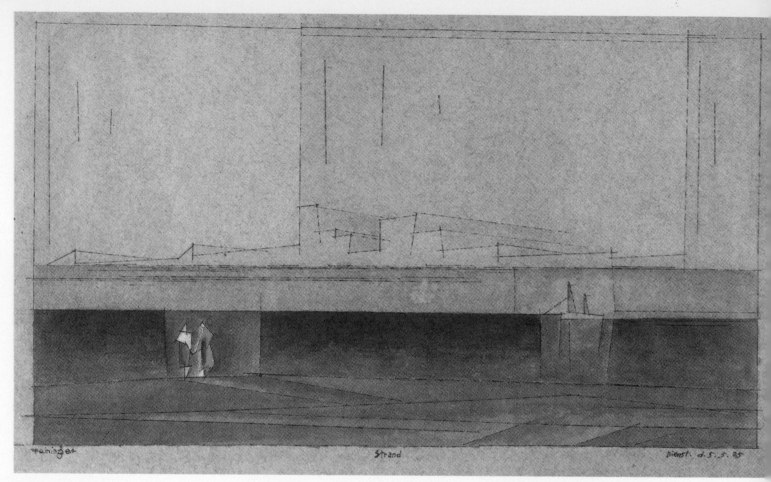

Plate 54

Lyonel FEININGER • *Strand, 1925* • ink and water color, 10 x 6 inches (sight) • The Brooklyn Museum

Plate 55

Otto DIX • *Café, 1922* • water color, 19¼ x 14⅜ inches • New York, The Museum of Modern Art, Gift of Samuel A. Berg

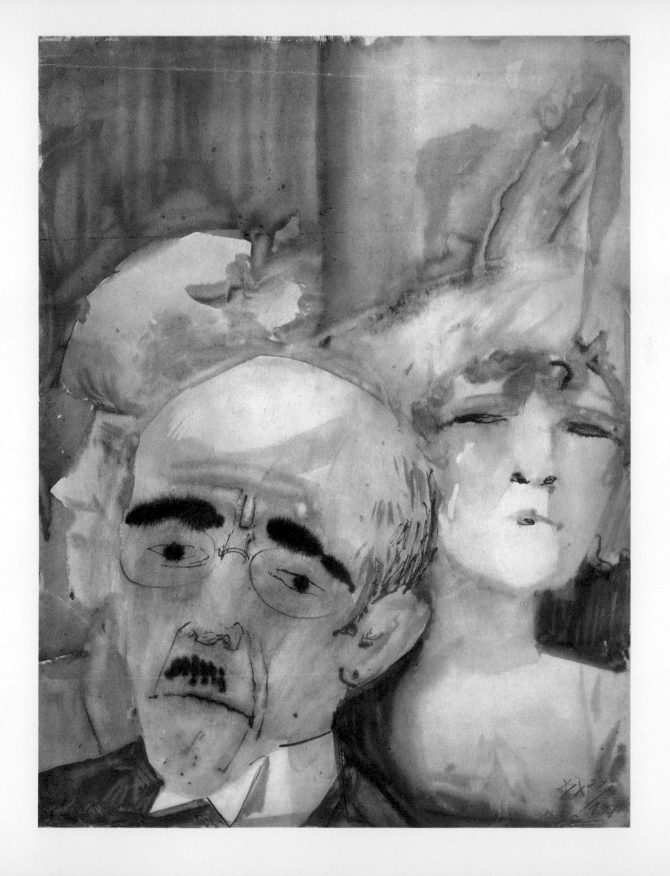

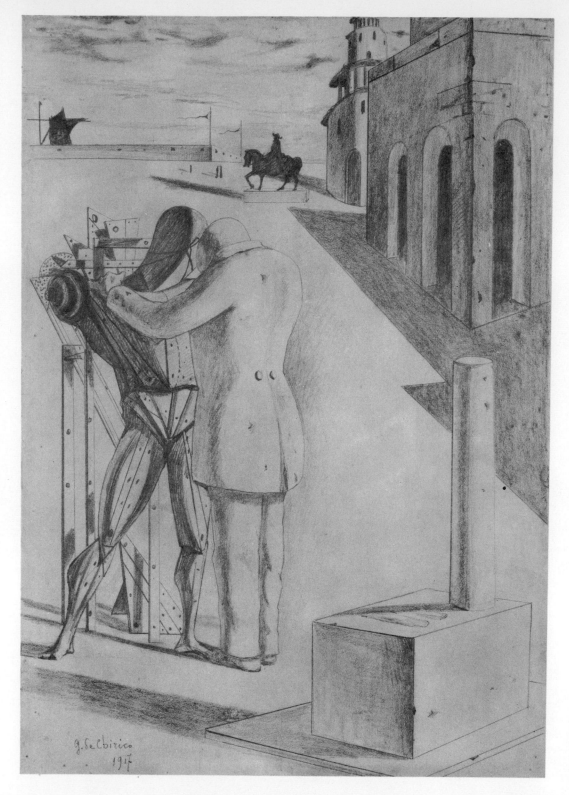

Plate 56
Giorgio de CHIRICO
The Return of the Prodigal, 1917
pencil, 11⁵⁄₁₆ x 8 inches
Kitchawan, New York
Mr. Herbert Rothschild

Plate 57
Juan GRIS
Portrait of Max Jacob, 1919
pencil, 14³⁄₈ x 10½ inches
New York
The Museum of Modern Art
Gift of James Thrall Soby

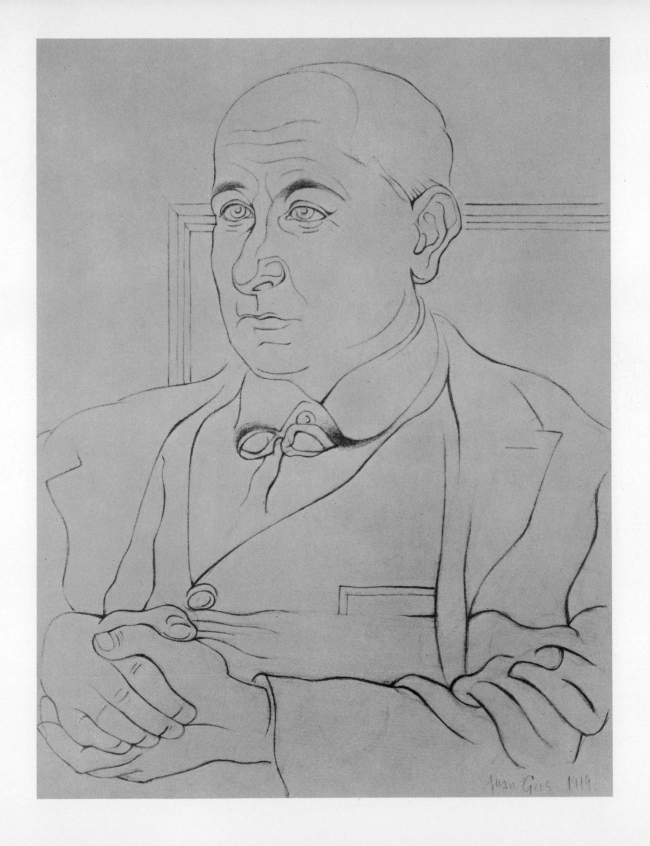

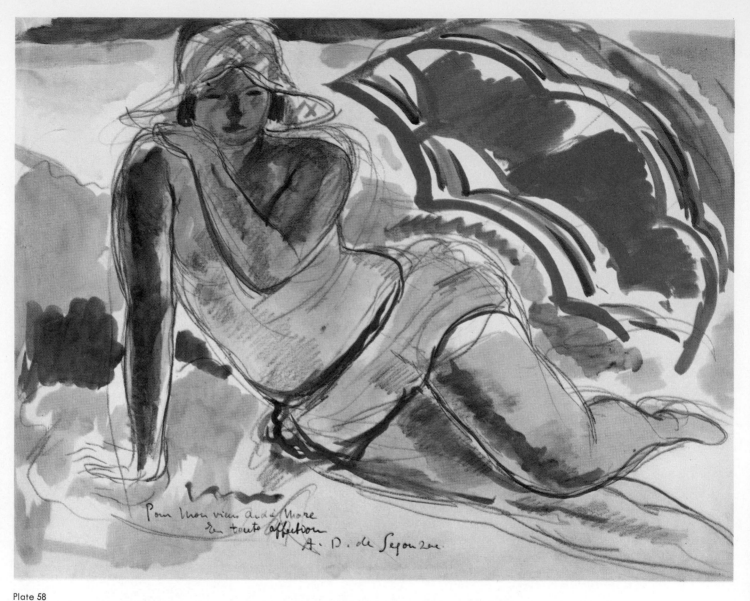

Plate 58
André DUNOYER DE SEGONZAC • *Young Girl with Red Umbrella, 1925* • pencil and water color, 24⅝ x 29⅞ inches (sight)
The Brooklyn Museum

Plate 59
Hannah HOECH • *Collage, 1922* • 17 x 14½ inches • New York, Dr. Charlotte Weidler

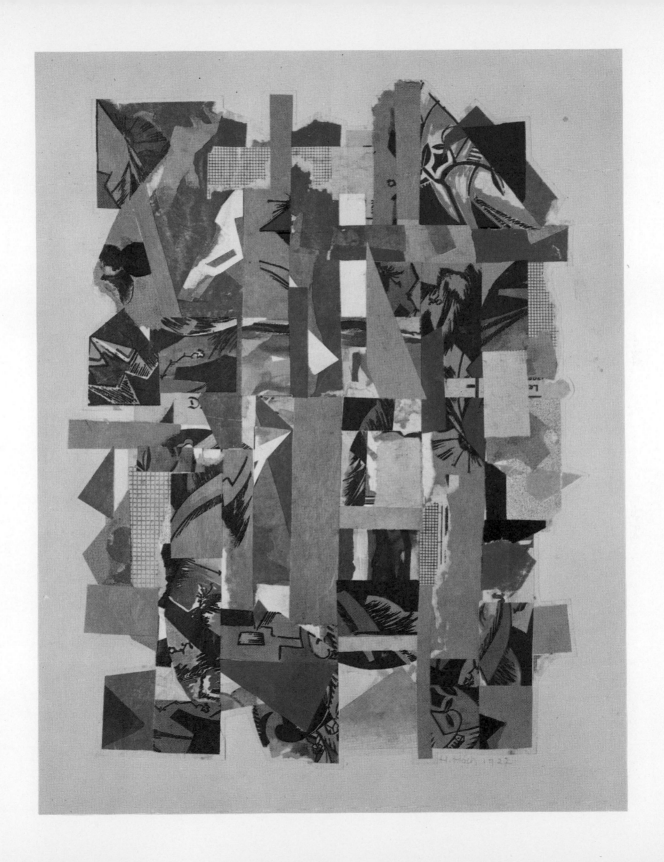

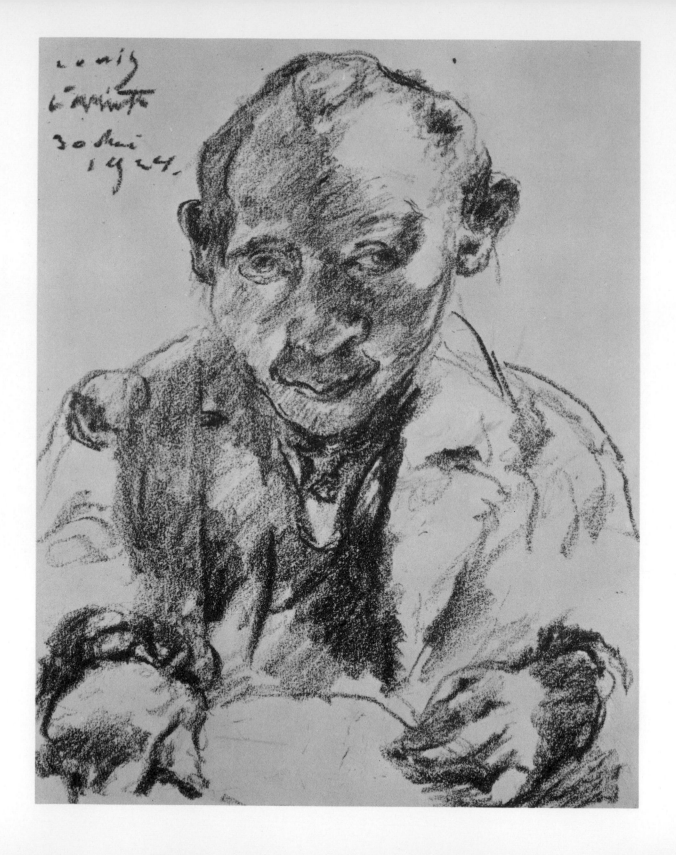

92

Plate 60
Lovis CORINTH
Self-Portrait, 1924
black crayon on white paper
12¼ x 9¾ inches
Cambridge, Mass.
Harvard University
Fogg Art Museum

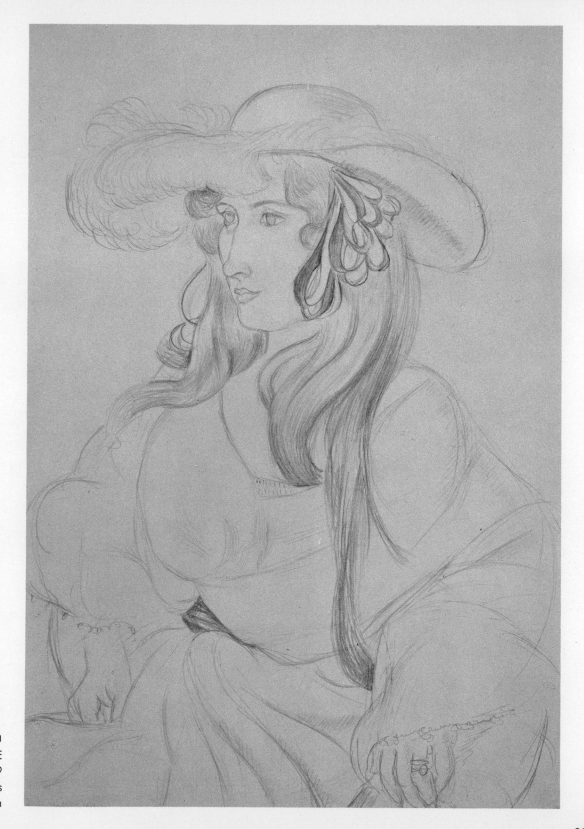

Plate 61
Henri MATISSE
The Plumed Hat, 1919
pen and ink, 20½ x 14 inches
Private Collection

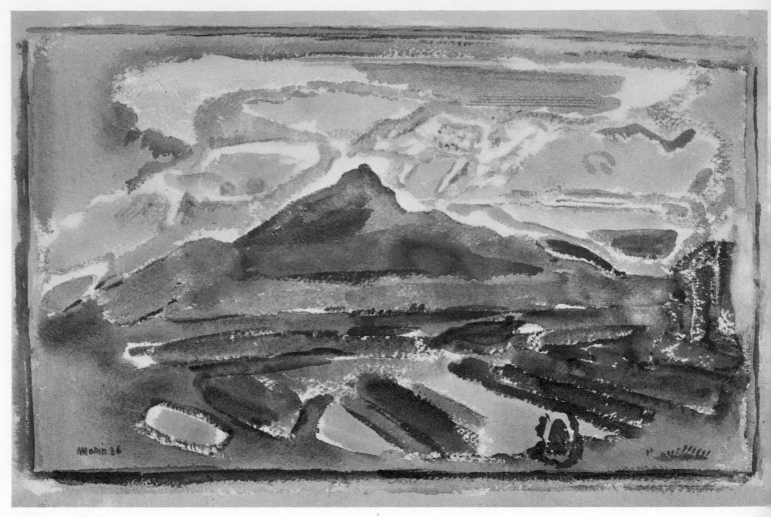

Plate 62
John MARIN • *Sunset, 1926* • water color, 13¾ x 21¼ inches • Private Collection

Plate 63
Max BECKMANN • *Portrait of Dr. Gottlieb Friedrich Reber, ca. 1929* • black chalk, 15¾ x 14⅞ inches • Cologr
Wallraf-Richartz Museum

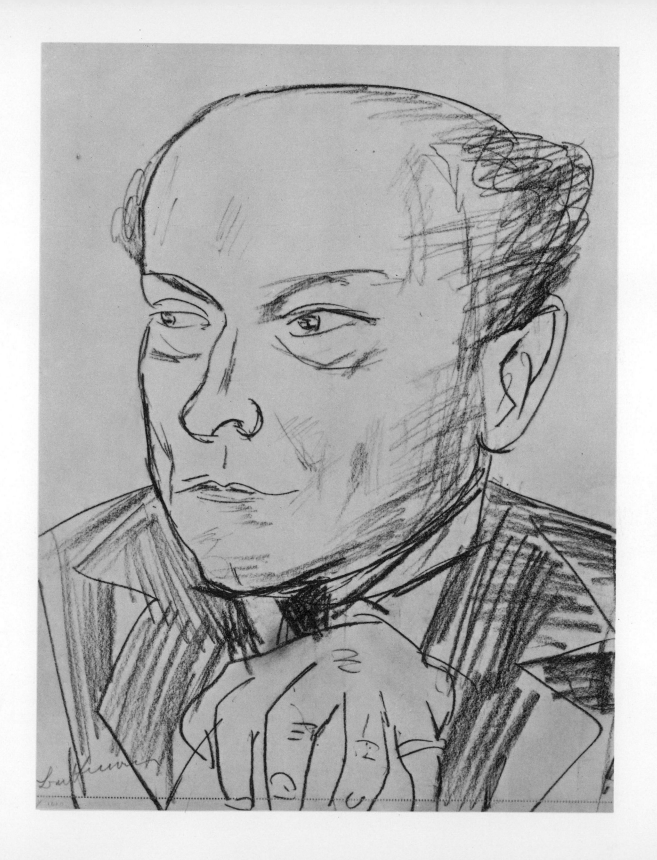

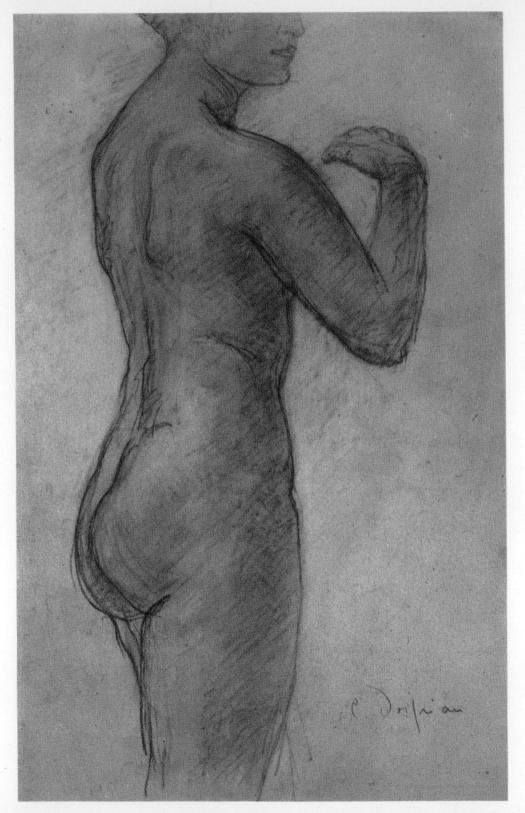

Plate 64
Charles DESPIAU
Nude, n.d.
red chalk, 14 x 8¾ inches
Private Collection

Plate 65
André DERAIN
Bust of a Woman, ca. 1924
red chalk, 23⅞ x 19⅜ inches
The Art Institute of Chicago
Gift of Mr. and Mrs. William
N. Eisendrath, Jr

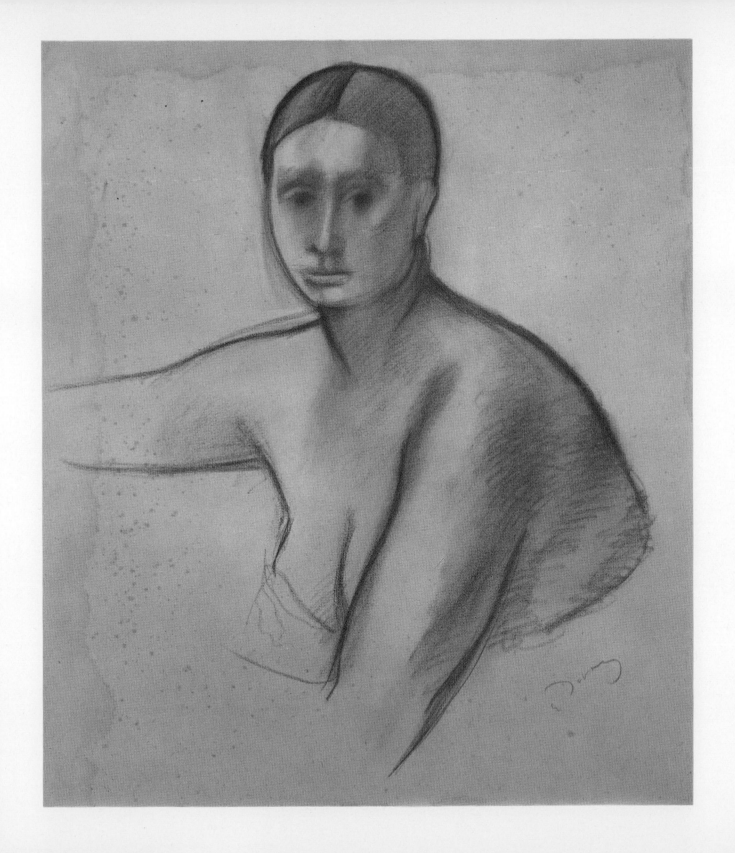

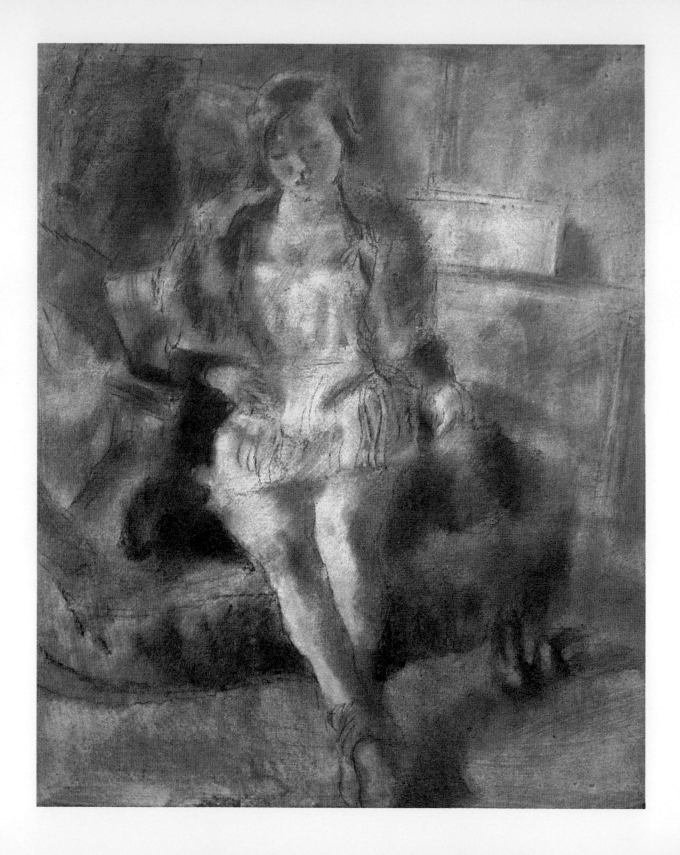

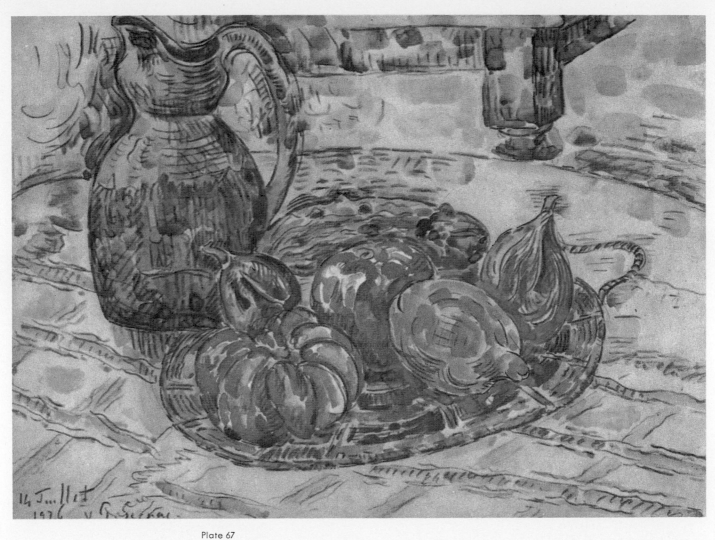

Plate 67
Paul SIGNAC · *Still Life with Pitcher and Fruit, 1926* · water color, 9 x 13¼ inches · Private Collection

Plate 66
Jules PASCIN · *Mireille, 1930* · pastel, 25 x 21¾ inches · Paris, Musée d' Art Moderne

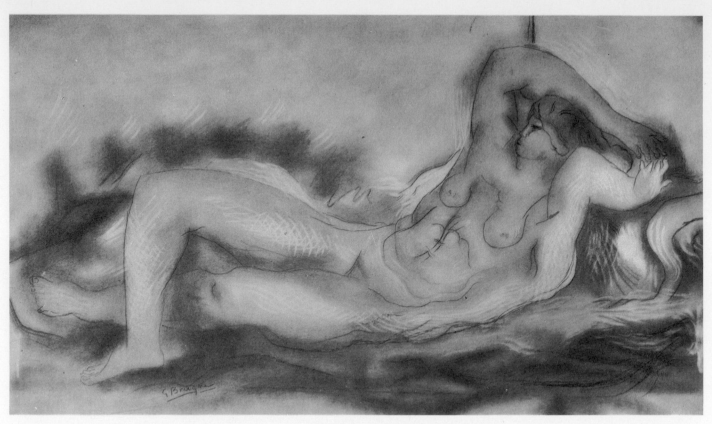

Plate 68
Georges BRAQUE • *Reclining Nude, 1924-26* • pencil, crayon and wash, 13⅞ x 23¾ inches • Private Collection

Plate 69
George GROSZ • *Charwoman, 1924* • pencil, 25⅝ x 20⅝ inches • The Brooklyn Museum, Dick S. Ramsay Fund

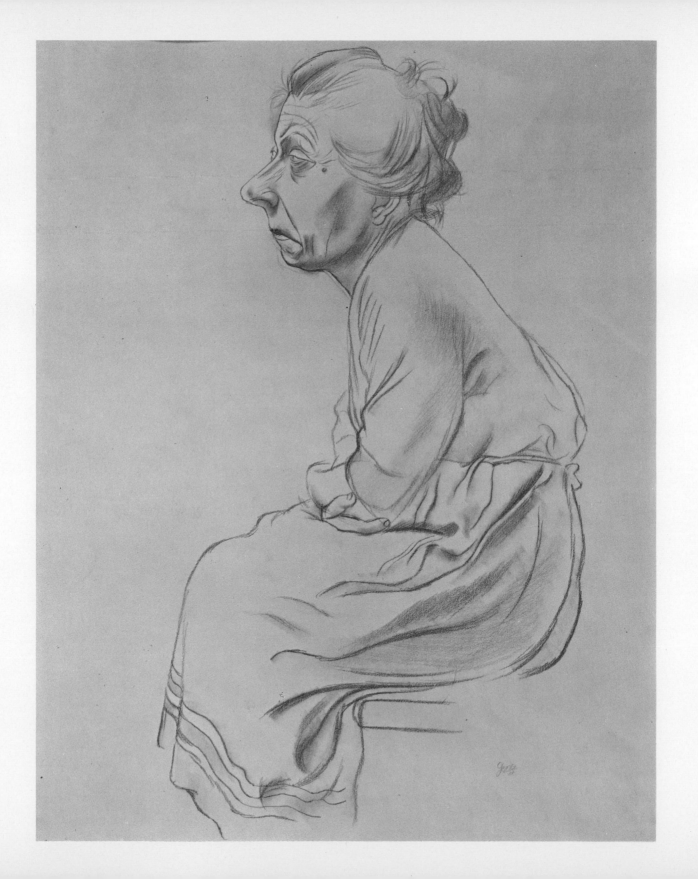

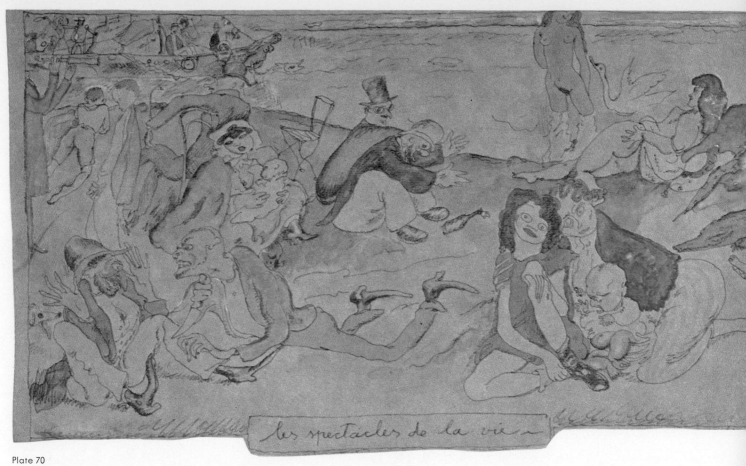

Plate 70

Jules PASCIN • *Spectacles of Life, n.d.* • pen and ink and water color, 6³⁄₁₆ x 10¾ inches
The Art Institute of Chicago, Gift of Tiffany and Margaret Blake

Plate 71
Vasily KANDINSKY
Light Cubes, 1932
water color on green-blue paper
18½ x 11⁄16 inches
Birmingham, Michigan
Mr. and Mrs. Harry Lewis Winston

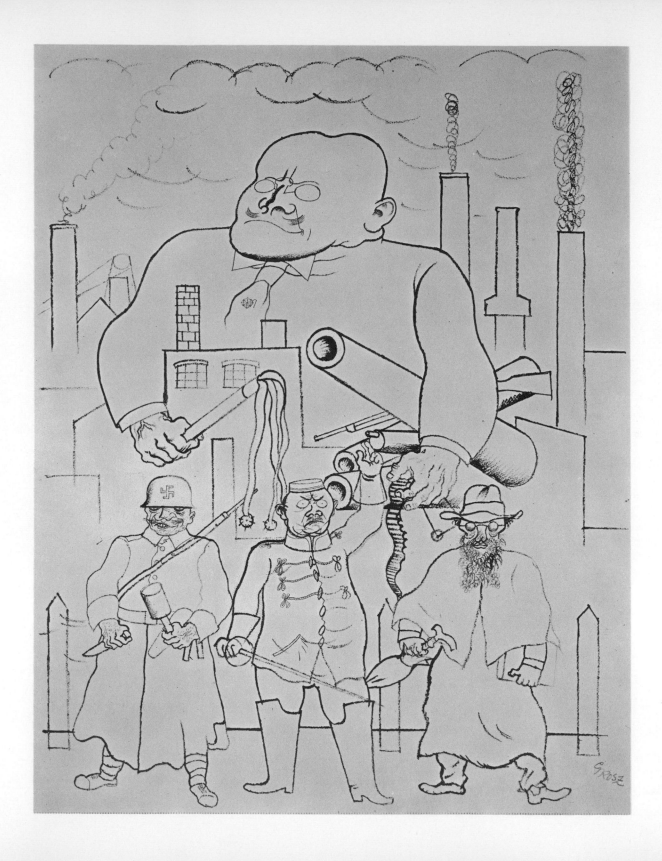

Plate 72
George GROSZ
The Ruler, ca. 1925
brush and black ink on
white paper, 21 x 17 inches
New York
Mr. and Mrs. Erich Cohn

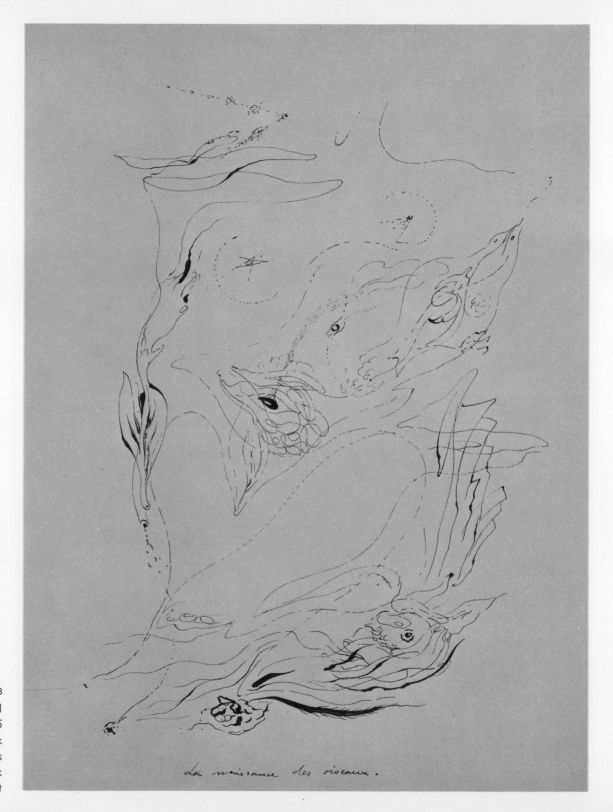

Plate 73
André MASSON
Birth of Birds, probably 1925
pen and ink
16½ x 12⅜ inches
New York
The Museum of Modern Art

La naissance des oiseaux.

105

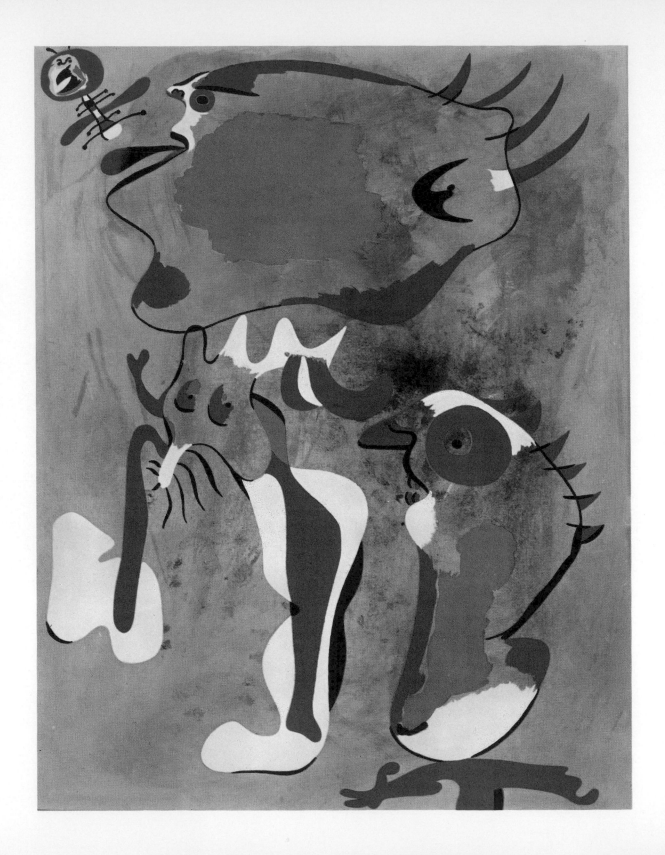

Plate 74
Joan MIRÓ
*Two Personages and
a Dragonfly*, 1936
gouache on beige paper
16¼ x 12¾ inches
Chicago, Richard Feigen Gallery

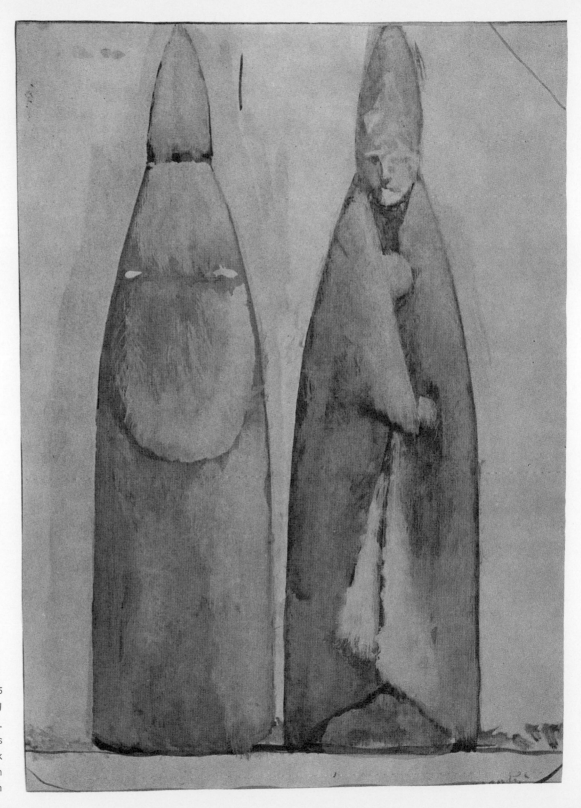

Plate 75
Giacomo MANZU
Cardinale (back and front), n.d.
gouache, 16 x 11¾ inches
New York
The Joseph H. Hirshhorn
Collection

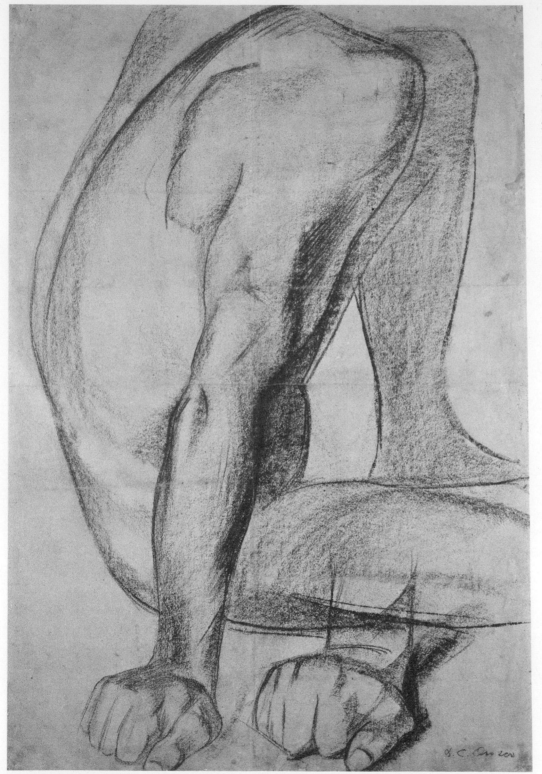

Plate 76
José Clemente OROZCO
*Study for National Preparatory
School Mural*, 1926
charcoal on brown paper
27¼ x 18⅝ inches
New York
Mr. and Mrs. Alexander Dobkin

Plate 7
Oskar SCHLEMME
*Sketch for an Oil Painting
Four Figures in Space*, 192
pencil, 10⅞₁₆ x 7¼ inches
Basel, Kupferstichkabine

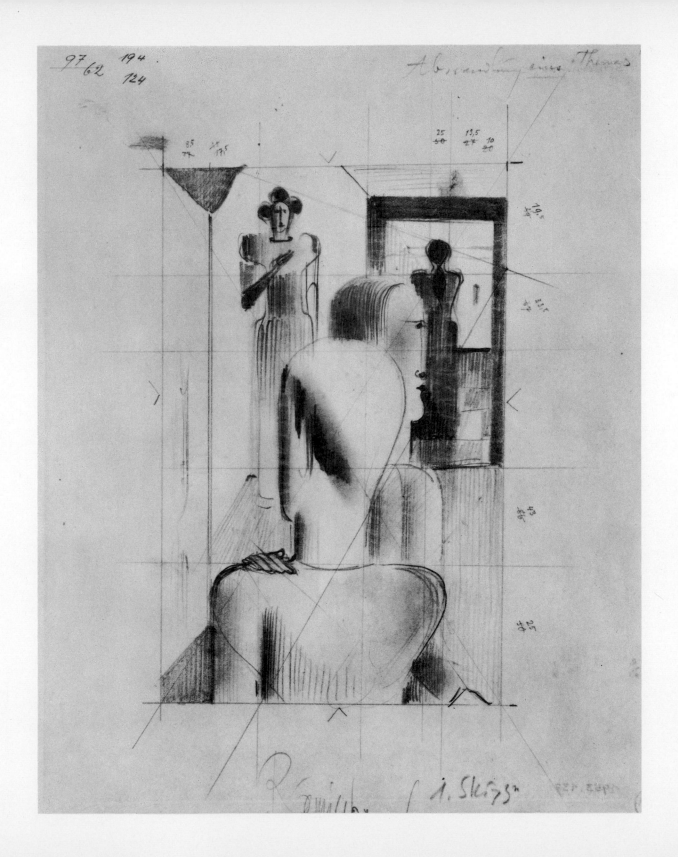

109 (at bottom right of page)

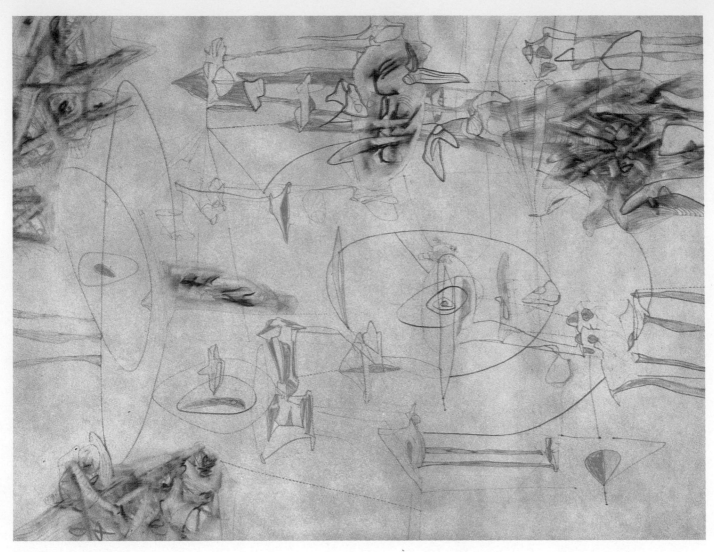

Plate 78
Roberto MATTA Echaurren · *Untitled Drawing, 1939* · crayon and pencil, 19⅝ x 25½ inches · Chicago, Richard Feigen Gallery

Plate 79
Joan MIRÓ · *Persons Haunted by a Bird, 1938* · water color over black and brown chalk, 16¼ x 12¾ i
The Art Institute of Chicago, Gift of Mr. and Mrs. Peter B. Bensinger

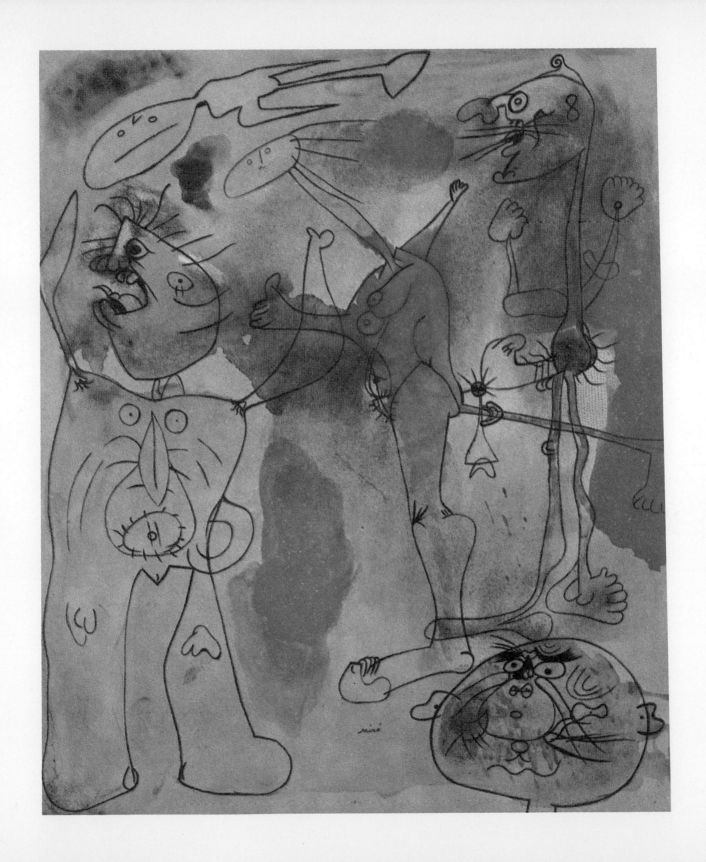

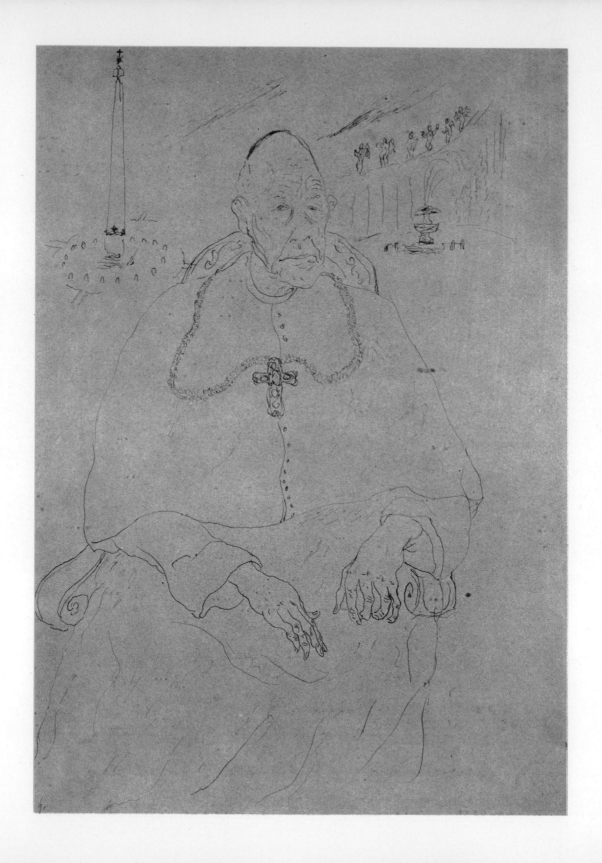

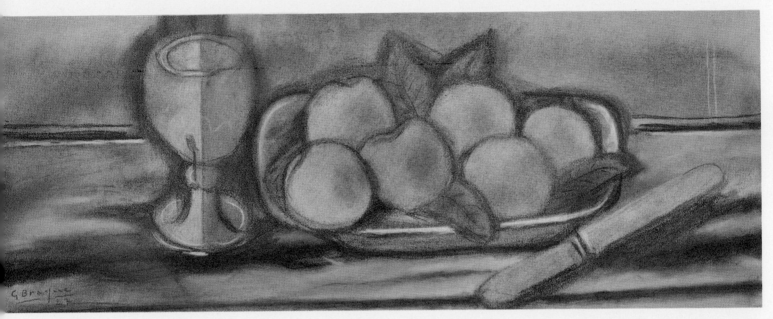

Plate 81

Georges BRAQUE · *Still Life with Glass, Fruit Dish and Knife, 1927* · pastel in reddish brown crayon, heightened with white, 10 15/16 x 25 11/16 inches
The Art Institute of Chicago, Gift of Mrs. Potter Palmer

Plate 80

SCIPIONE · *Portrait of a Cardinal, ca. 1929* · pen and ink on tan paper, 12 7/8 x 9 1/4 inches · Rome, Enrico Falqui

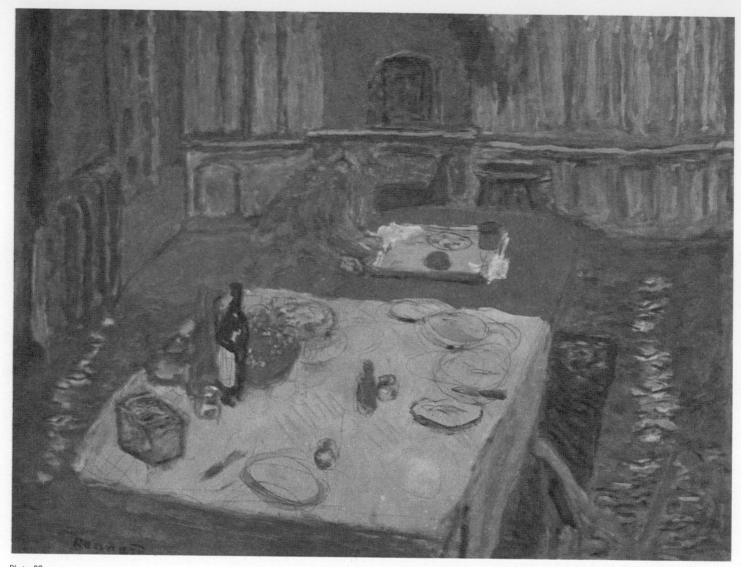

Plate 82

Pierre BONNARD • *Still Life: Preparation for Lunch, 1940* • gouache, 19⅝ x 25⅝ inches • The Art Institute of Chicago
The Olivia Shaler Swan Memorial Fund

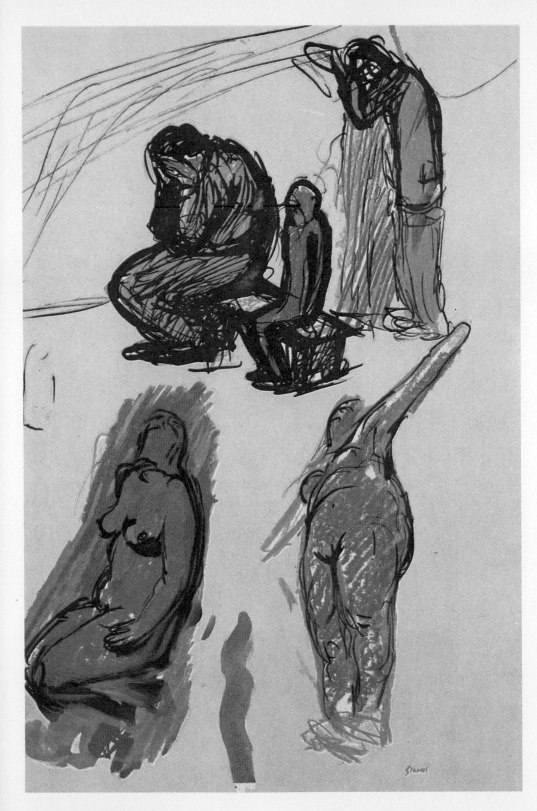

Plate 83
Mario SIRONI
Sheet of Studies, ca. 1939
pen and ink, colored crayons
12½ x 8 inches
Private Collection

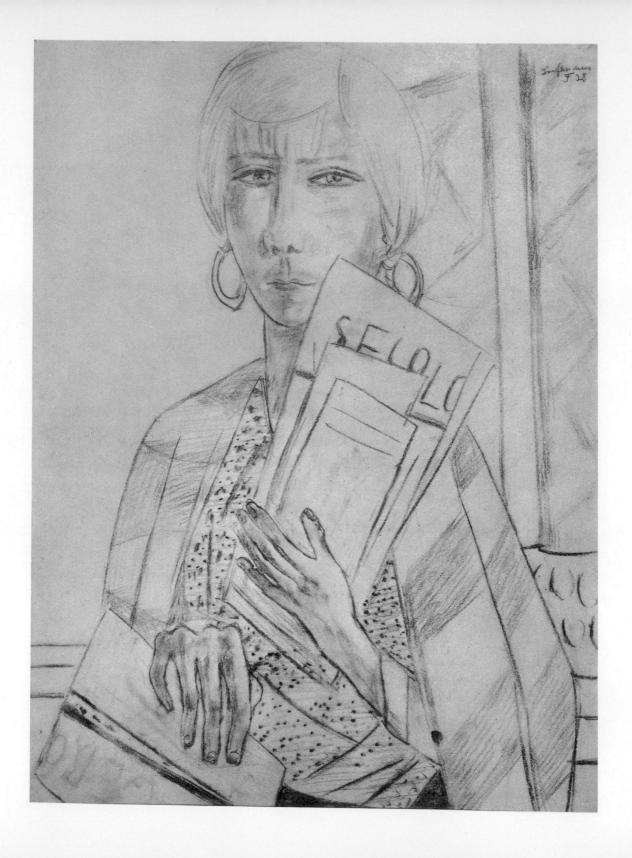

Plate 84
Max BECKMANN
Newspaper Seller, 1928
black chalk on white paper
25 x 19⅛ inches
Private Collection

Plate 85
Édouard VUILLARD
Portrait of Mme Vuillard, n.d.
pencil on light beige paper
8⅛ x 4⅝ inches
New Haven, Yale University Art Gallery
Edward B. Greene Fund

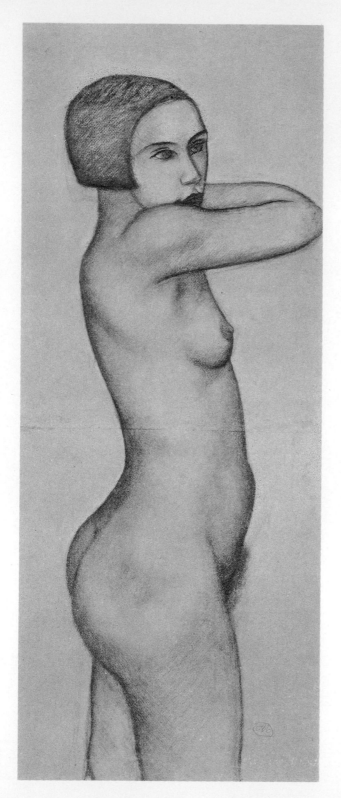

Plate 86
Aristide MAILLOL
Nude with Raised Arm, ca. 1929
charcoal, 44 x 17¾ inches
New York
The Joseph H. Hirshhorn Collection

Plate 87
Georges BRAQUE
Collage, n.d.
11¾ x 8½ inches (sight)
The Art Institute of Chicago

118

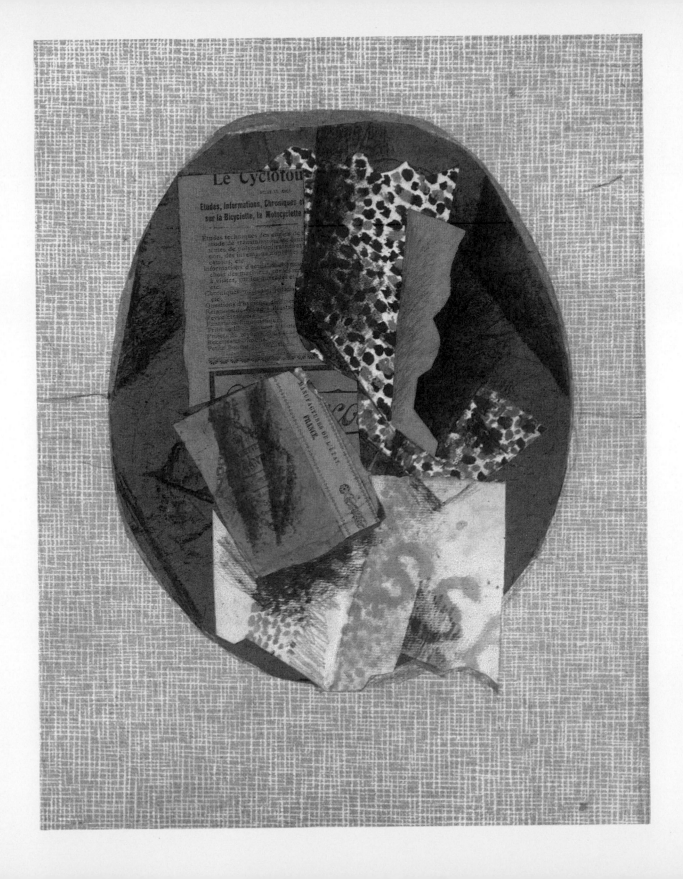

119

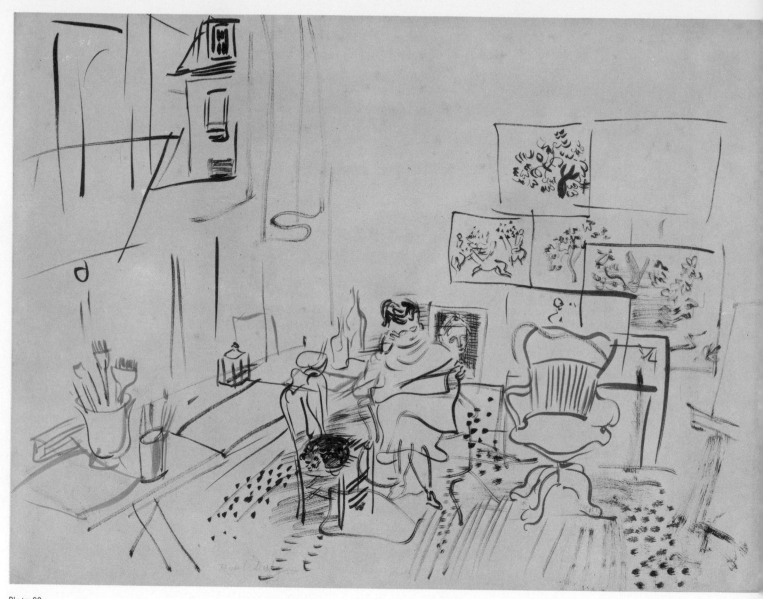

Plate 88

Raoul DUFY · *The Artist's Studio, n.d.* · brush and ink, 15⅞ x 26 inches · New York · The Museum of Modern Art
Gift of Mr. and Mrs. Peter A. Rubel

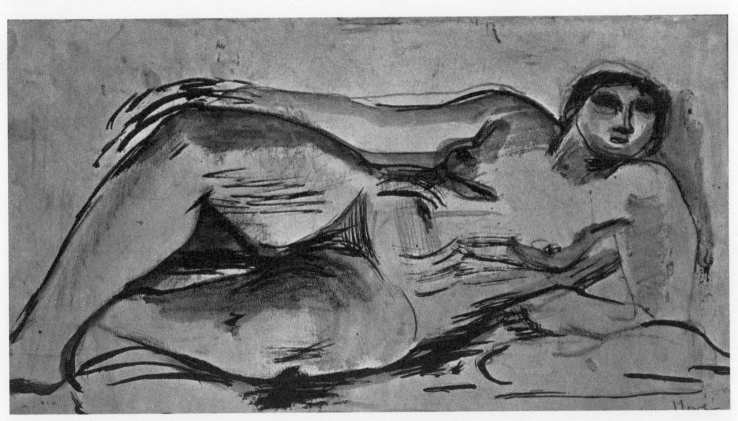

Plate 89
Henry MOORE • *Reclining Nude, 1931* • brush and wash in sepia, 9 15/16 x 18 1/4 inches • London, Victoria and Albert Museum

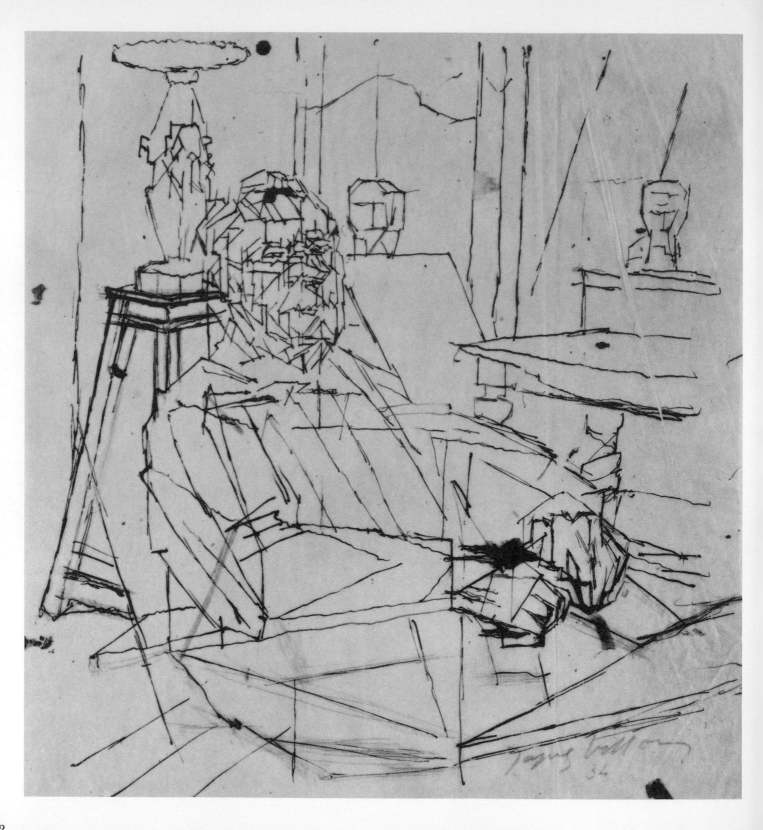

122

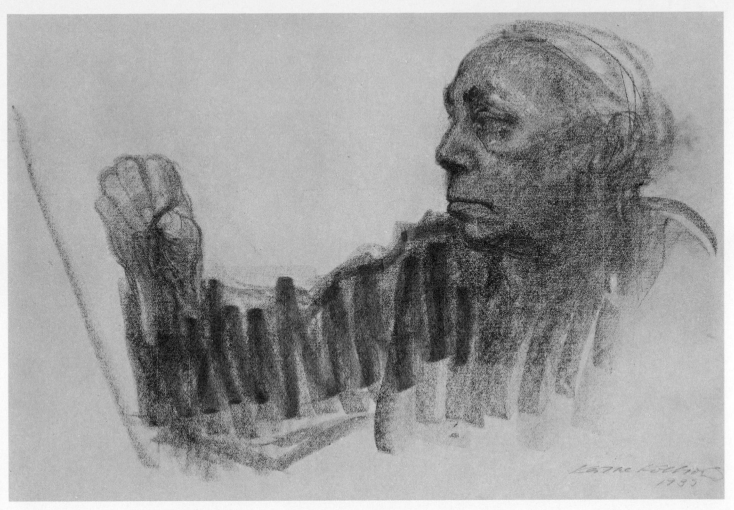

Plate 91
Kaethe KOLLWITZ • *Self-Portrait with a Pencil, 1933* • charcoal, 18¾ x 25 inches • Washington, D. C.
National Gallery of Art, Rosenwald Collection

Plate 90
Jacques VILLON • *Self-Portrait, 1934* • pencil and India ink on tracing paper, 9 ¹¹⁄₁₆ x 8⅞ inches • Paris, Galerie Louis Carré

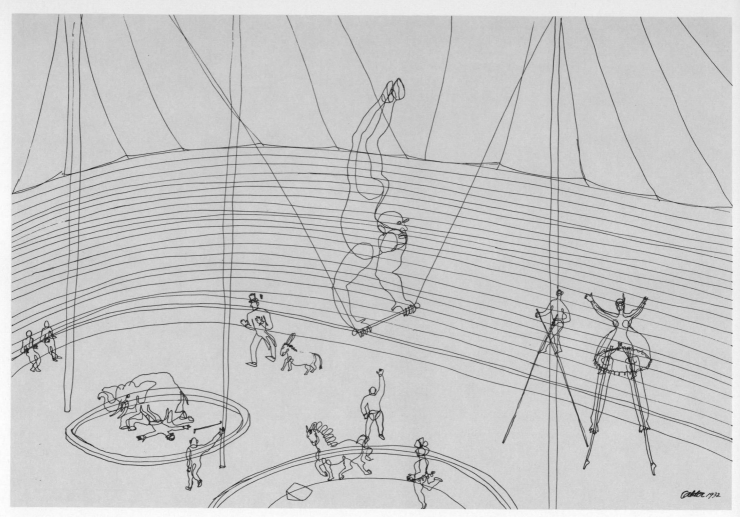

Plate 92
Alexander CALDER • *The Circus, 1932* • pen and ink on white paper, 20¼ x 29¼ inches • New York, Mr. and Mrs. Klaus G. Perls

Plate 93
Fernand LÉGER • *The Saltimbanques, 1940* • charcoal, 39 x 34¼ inches • New York, Mr. and Mrs. Daniel Saidenberg

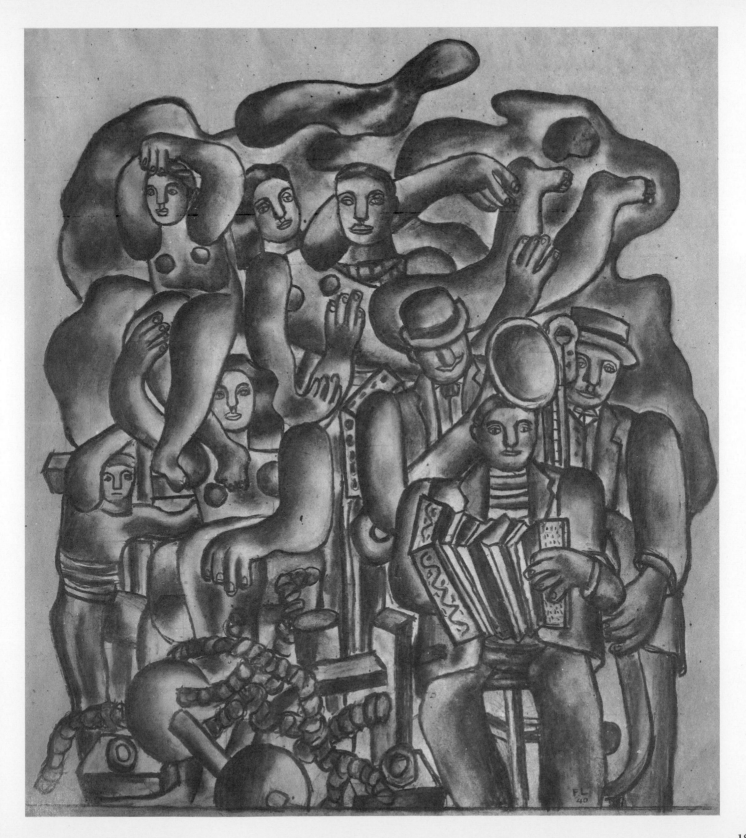

125

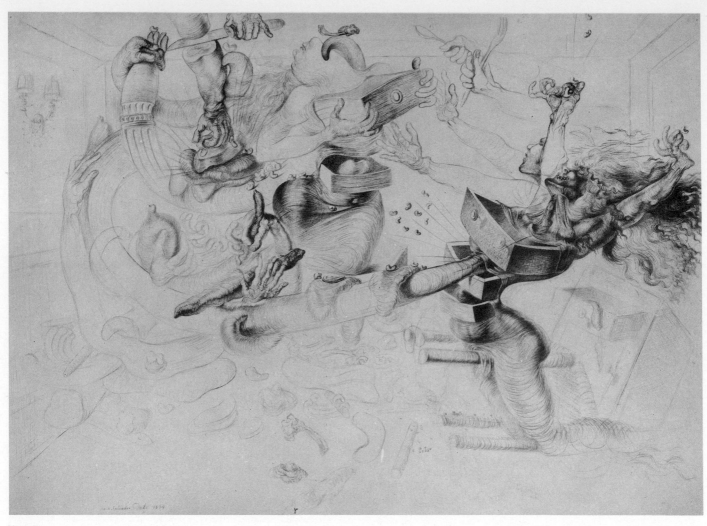

Plate 94

Salvador DALI • *Composition of Figures of Drawers, 1937* • brush and India ink on white paper, 21½ x 29⅞ inches
Cambridge, Mass., Harvard University, Fogg Art Museum

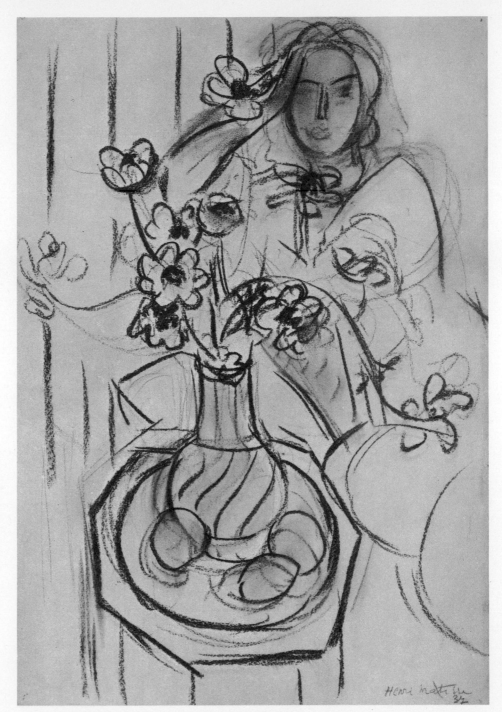

Plate 95
Henri MATISSE
Woman and Vase of Flowers, 1932
charcoal on yellowish paper
22 x 15 inches
New York
The Joseph H. Hirshhorn
Collection

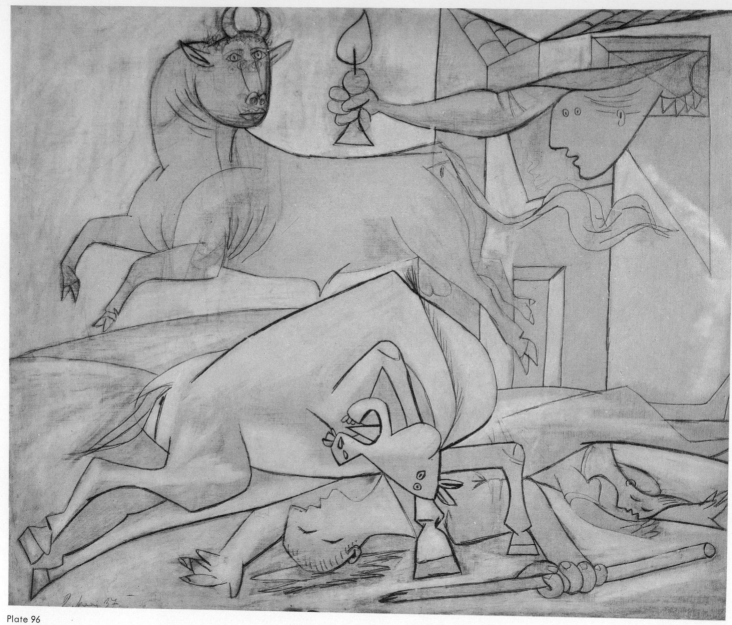

Plate 96

Pablo PICASSO · *Composition Study for "Guernica," 1937* · pencil on gesso, 23⅝ x 28¾ inches · New York
The Museum of Modern Art, Gift of the Artist

Biographies

BALLA Giacomo Balla (1871-1958) was an Italian painter and one of the founders of Futurism. His realization of its aims, to represent successive stages of action, was particularly shown in pictures painted between 1913 and 1916.

BARLACH Ernst Barlach (1870-1938) was the most important German Expressionist sculptor and illustrator during the two World Wars. At first a member of *Jugendstil,* after a trip to Russia he made woodcarvings of peasants and beggars. Barlach's pessimistic art was condemned by the Nazis, and much of his work was destroyed. Technically, his woodcarvings were based on German Late Gothic work.

BECKMANN Max Beckmann (1884-1950) was one of the German Expressionists. The subjects of his etchings and paintings were taken from everyday life: the city, the circus and fairs—used as symbols hinting at contemporary dangers. His major works were seven triptychs interpreting mythological themes and drawing comparisons between real life and the stage.

BOCCIONI Umberto Boccioni (1882-1916) was one of the original Italian Futurists, signing the Manifesto of 1910 and issuing the Manifesto of Futurist Sculpture in 1912. He achieved the effect of movement in such subjects as a man walking by representing successive stages of action in a single image.

BONNARD Pierre Bonnard (1867-1947) was influenced by Art Nouveau and was one of the French symbolists, the *Nabis.* He became associated with *Intimisme,* which was based on Impressionist techniques. His subjects (landscapes, gardens with flowers, sailing boats and female nudes) were composed "from memory."

BRANCUSI Constantin Brancusi (1876-1957), the Rumanian sculptor, was perhaps the most completely abstract of modern sculptors. He usually confined himself to one single, simple, highly-polished shape.

BRAQUE Georges Braque (1882-1963), one of the masters of 20th-century French painting, was associated in 1906 with the Fauves. In 1909 he began, with Picasso, to work out the basis for a new approach to painting which later developed into Cubism. After World War I he attempted to revive Synthetic Cubism but abandoned it to concentrate on still-life and figure compositions.

CALDER Alexander Calder (b. 1898), an American sculptor, was originally an engineer. He invented Stabiles and Mobiles, which can be regarded as a marriage between engineering and sculpture.

CARRÀ Carlo Carrà (b. 1881) was one of the original Italian Futurists and later joined Chirico in his *Pittura Metafisica*. Thus he has belonged to both major modern Italian movements. Later he reverted to a more naturalistic mode.

CHAGALL Marc Chagall (b. 1887), a Russian painter, had fully formed his highly-imaginative style by 1923, and was painting more or less recognizable objects in unusual juxtaposition, apparently floating in space. Most of his subjects are poetic evocations of Russian village life and religious themes. His fantasies have greatly influenced the Surrealists.

CHIRICO Giorgio de Chirico (b. 1888) is an Italian painter who founded the quasi-Surrealist *Pittura Metafisica* movement. In the 1930's he abandoned his "modern" ideals and returned to a form of imitation of the Old Masters.

CORINTH Lovis Corinth (1858-1925) was one of the leading German Impressionists. His early work was in the style of Leibl and Courbet. His choice of epic subjects, his interest in facial expressions and his basically tragic view of life were all fundamentally different from French Impressionism. It was only a short step from Corinth to Expressionism.

DALI Salvador Dali (b. 1904), born in Spain, was originally a Cubist and became one of the leading Surrealists. His treatment of nightmares, hallucinations, delusions and other mental aberrations done with clear, coldly-painted figures are often finished with photographic exactness.

DELAUNAY Robert Delaunay (1885-1941) was initially linked with Cubism. His greatest contribution lay in the use of color and formal analysis. His method of super-

imposing transparent planes of color affected Cubism in its later stages and also had a strong influence on the German painters Marc and Macke.

DEMUTH Charles Demuth (1883-1935) was an American painter strongly influenced by Cézanne and Cubism. His work is a synthesis of Cubism and the Realist tradition. He preferred architectural subjects, especially in the industrial field.

DERAIN André Derain (1880-1954) was a member of the French Fauves and is considered to have "discovered" Negro art. In his later years he showed classical leanings and devoted himself to the study of the Old Masters.

DESPIAU Charles Despiau (1874-1946) was a French sculptor who originally worked in the impressionistic style of Rodin. His forms gradually became firmer and more disciplined and his sculpture closer to the manner of Maillol.

DIX Otto Dix (b. 1891) was a German painter who was a pitiless realist, even in his portraits, which are not as caricatural as Grosz's. He was naturally attracted to the *Neue Sachlichkeit* group. Since 1946 he has painted mainly religious subjects. In his later works the influence of early German masters such as Altdorfer and Baldung has been evident.

DOVE Arthur Dove (1880-1946) is claimed to be the first of the Abstract painters. Painting in America, he was ahead of Kandinsky in Europe in breaking away from all direct representational reference to subject matter. By 1910 he had painted the geometrically-formed *Abstraction No. 2* of the landscape near his home.

DUCHAMP Marcel Duchamp (b. 1887), a French painter, was one of the original Dadaists. Before the invention of Dada, he had shocked New York with his *Nude Descending a Staircase* in the Armory Show of 1913.

DUFY Raoul Dufy (1877-1953), a French artist, dropped his early Impressionist manner when he saw Fauve painting. He developed further the decorative element in Fauvism and applied it when he became textile artist for a fashion designer. He also had a gift for monumental wall decoration, demonstrated by his *Hall of Electricity* at the New York World's Fair in 1939. He is known for his landscapes, which even when done in oil, retained the freshness of water colors.

DUNOYER DE SEGONZAC André Dunoyer de Segonzac (b. 1884), a French landscape painter, often preferred the winter countryside, where the structure that provided him suitable subjects for his subtle, rhythmic line was clearly revealed. He was influenced by the Flemish masters, and by Courbet and Cézanne. His style as a draughtsman crystallized early in his career.

FEININGER Lyonel Feininger (1871-1956) was originally a caricaturist. Later the American Feininger came into contact with the Cubists, Delaunay and Der Blaue Reiter group. He transformed Cubism in a poetic and romantic way in paintings of seemingly-transparent rainbow hues. In 1919 he joined the Bauhaus and kept up the association until its dissolution in 1933. After his return to America in 1937, his sensitive atmospheric painting—formerly of old German towns—began to feature New York skyscrapers.

FRESNAYE Roger de La Fresnaye (1885-1925) was a French painter who participated in each modern trend from Symbolism to Cubism. Later, landscape and still-life paintings in a more traditional manner developed from his Cubist phase.

GERSTL Richard Gerstl (1883-1908) cut short his four-year career by suicide. Because of his unconventional artistic approach, this Austrian artist's studies at the Vienna Academy ended early. His work was shown for the first time in the early 1930's, but interest in them was suppressed with the rise of Hitler. All but seven of his drawings (self-portraits) and 56 paintings were burned by the artist.

GLEIZES Albert Gleizes (1881-1953) was a Parisian Cubist painter who attempted to represent animation in pictorial terms. After 1917 his work showed an increasing preoccupation with religious subjects.

GRIS Juan Gris (1887-1927) left Madrid in 1906 and settled in Paris. At first he treated objects in his pictures as many-faceted planes. By 1911 he used the analytical form of Cubism, and later used collage and synthetic forms with an understanding and originality that save him from inclusion among the more obvious imitators of Picasso.

GROSZ George Grosz (1893-1959) was a German caricaturist and, after World War I, produced lithographs exposing post-war conditions with biting sarcasm. In

them he attacked militarism, philistinism, and bureaucracy and capitalism with equal venom. After coming to New York in 1933, he turned to water colors of the city and rather Baroque still life. During World War II he painted symbolic, terror-filled anti-war pictures which rank as the most powerful of the kind.

HECKEL Erich Heckel (b. 1883) was one of the founders and most active members of Die Brücke and among the most important representatives of German Expressionism. He excels in the field of graphic art, especially lithography and woodcuts.

HOECH Hannah Hoech (b. 1895) is a German artist who was one of the original members of the Berlin Dada movement. Originally noted for her collages and photo-montages, she turned to Surrealism after the International Dada Fair in 1920. Since World War II she has worked with gouache and aquarelle.

JOHN Augustus Edwin John (1878-1961) was strongly influenced by Puvis de Chavannes and Postimpressionism from 1910 to 1914. Later his portraits derived from the grand-manner tradition enlivened by a semi-Impressionist handling of color and a very un-Impressionist solidity of drawing.

KANDINSKY Wassily (Vasily) Kandinsky (1866-1944) painted his first completely abstract work in 1910, and was therefore one of the founders of "pure" abstract painting. In 1911 he was one of the founders of Der Blaue Reiter group. In 1912 he published a book which was translated into English in 1914 as *The Art of Spiritual Harmony*. He taught at the Bauhaus after 1922.

KIRCHNER Ernst Ludwig Kirchner (1880-1938) was the founder of the German Expressionist Die Brücke movement. Influenced by African sculpture and old German woodcuts, his paintings—based first on metropolitan themes, later on alpine life and scenery—reflect a tragic outlook and great loneliness in their angular, broken forms.

KLEE Paul Klee (1879-1940), Swiss painter and etcher, was a member of Der Blaue Reiter group and later taught at the Bauhaus. His art of free fantasy is defined in his own words as "taking a line for a walk." He is considered one of the greatest innovators of the 20th century.

KLIMT Gustav Klimt (1862-1918) was a founder-member of the Vienna Secession, whose style at the turn of the century, a mixture of *Jugendstil*, Naturalism and English *fin de siècle*, combined with a distant influence of French Neo-Impressionism and Symbolism. Klimt's work was typical of Art Nouveau with beautifully-ornamented surfaces, flowing curves and delicate figures.

KOKOSCHKA Oskar Kokoschka (b. 1886) is an Austrian painter who developed a highly-imaginative Expressionist style between 1908 and 1914. Influenced by painters who had worked in Die Brücke group, his portraits, landscapes and town views are often seen in bird's-eye-view. His colors are vivid and his drawings restless. He has also painted allegories inspired by legends.

KOLLWITZ Kaethe Kollwitz (1876-1945) was a German graphic artist. Her early illustrations were of historical themes. Later scenes were taken mainly from the life of the working class in Berlin. She also produced sculptures in an idiom related to Barlach.

LARIONOV Michael Larionov (b. 1881) was the foremost member of the Russian avant garde before World War I. Initially a Cubist, by 1911 he had adopted a new manner of working which became known as Rayonism. He was among the first of his generation to work in a fully abstract way.

LE CORBUSIER Le Corbusier (b. 1887), whose real name is Charles Édouard Jeanneret, is a Swiss architect whose revolutionary ideas about modern living emphasize air, light, sun and, above all, space, to which the past had never attributed importance. The open plan, with movable partition walls, is one of his favorite devices. Originally trained as a copper-plate engraver, he has continued to work also as a painter and graphic artist.

LÉGER Fernand Léger (1881-1955) was a French painter whose early block-like figures evolved, ca. 1917, into a form of curvilinear Cubism based on the geometrical shapes of machinery with brilliant metallic surfaces. These forms also influenced his massive, robot-like figures and increased the effect of his clear grays and strong, unbroken colors.

MACKE August Macke (1887-1914) was a German painter deeply influenced by contemporary French painting, particularly by Delaunay's bright color used with

near-Cubist ideas. Associated with Marc and Kandinsky in Der Blaue Reiter, and also influenced by Futurist ideas, he remained a more representational artist than these associations suggest.

MAILLOL Aristide Maillol (1861-1944) was a French painter and tapestry designer originally, but turned exclusively to sculpture after 1900. Disregarding the 19th-century approach with its overemphasis on gestures, he turned to a controlled synthesis of plastic forms. His subject was almost always the female nude with a strength and proportion that is found in the sculptures of classical antiquity.

MANZU Giacomo Manzu (b. 1908), an Italian sculptor, was initially influenced by Rodin and Degas. While primarily interested in character, his rendering of facial expressions often leads him to the point of caricature.

MARC Franz Marc (1880-1916) was a German Expressionist painter in Der Blaue Reiter group. His chief subjects were animals. Variations on the theme of the Blue Horse are perhaps his best-known works.

MARCOUSSIS Louis Marcoussis (1883-1941) associated with Cubism early, but later joined the *Section d'Or,* a group which combined Fauve color with Cubist form. He manipulated the color scale as a means of producing pure harmonies based on color proportions. Instead of analyzing the object, he analyzed only the pictorial element.

MARIN John Marin (1870-1953) became one of America's leading water-colorists after several years of study in Paris. Known chiefly for his scenes of the coast of Maine and New Jersey, his style consists of tilting planes and stenographic symbols.

MARQUET Albert Marquet (1875-1947) was one of the original French exhibitors at the Fauve show in 1905 but never shared with the ideas or the style of the Fauvists. He was a latter-day Impressionist, specializing in simple landscapes and town views.

MASSON André Masson (b. 1896) is a French Surrealist painter. His later work is divided between the Expressionist and the calligraphic style. He makes frequent use of bird and plant motifs.

MATISSE Henri Matisse (1869-1954) was a French sculptor and painter, the leading representative of Fauvism. Renouncing academic style, he developed instead along a Postimpressionistic line of brighter, simpler design and has influenced the development of 20th-century painting and design by his use of large surfaces of pure color, reducing aerial perspective to a minimum.

MATTA Roberto Matta Echaurren (b. 1912) is a Chilean painter, now living in Paris. Matta turned from abstract surrealism to compositions which employ planes and orbits in intricate relations, with galaxies of "things" that expand infinitely.

MIRÓ Joan Miró (b. 1893) is a Spanish Surrealist painter who has worked mainly in Paris. In 1925 he took part in the First Surrealist Exhibition and, with Dali, was recognized as one of the leading Surrealists. His later work has become more abstract.

MODIGLIANI Amedeo Modigliani (1884-1920) was an Italian painter whose first works were influenced by Toulouse-Lautrec, but his mature style was based on African sculpture. He was a superb draughtsman and his work contains echoes of the Sienese Trecento, Botticelli and some of the Mannerists.

MONDRIAN Piet Mondrian (1872-1944) was a Dutch painter who lived in Paris, London and New York. His form of abstractionism was especially rigorous, known as Neo-Plasticism, which consisted principally of restricting forms to purely geometrical shapes, set at right angles to the horizontal or vertical axis and colored in the three primary colors, and white, black or gray.

MOORE Henry Moore (b. 1898), the English sculptor, in his early phase sought to bring back to sculpture the effect of square mass and "block rhythms" in a style whose forms were related to Egyptian and Pre-Columbian sculpture. He has worked in stone, wood and bronze with equal effect, sometimes piercing the material.

MUNCH Edvard Munch (1863-1944), a Norwegian painter, was one of the forerunners of Expressionism. Much influenced by Gauguin, his subjects, especially his *Frieze of Life* project, dealt with love and death, for which he sought pictorial equivalents.

NOLDE Emil Nolde (1867-1956) was a German Expressionist painter of landscapes, biblical scenes and figure subjects based on a private mythology. In travel through Russia, China, Japan and Polynesia, he was impressed by the demonic quality of primitive art and religion.

OROZCO José Clemente Orozco (1883-1949) was an etcher, lithographer, draughtsman, and became internationally famous as a muralist. It was he, more than any other Mexican artist, who articulated the aims of the Revolution of 1917 in his great decorations for the National Preparatory School and other public buildings by using forms reminiscent of the Italian Renaissance, but transforming the iconography of that devotional epoch into modern terms full of power and meaning to this century.

PASCIN Jules Pascin (1885-1930) was a superb French draughtsman who found his inspiration for his work in the life of the Paris cafés. His paintings express a personal mysticism blended with eroticism. He drew through sheets of carbon paper to obtain contours and linear rhythms.

PECHSTEIN Max Pechstein (1881-1955) was a member of Die Brücke. His love for primitive art took him to the South Pacific in 1914 where, in the years following, he did his best work.

PICABIA Francis Picabia (1878-1953) was a Spanish artist who lived in Paris, New York and Barcelona. He was successively an Impressionist and a Cubist, was one of the most inventive Dadaist and Surrealist artists and painted in both abstract and representational manners.

PICASSO Pablo Picasso (b. 1881) is a Spanish painter who studied and lives in Paris. His early works (1906-09) were conventional and named for their dominant colors, "blue" and "rose." Influenced by Iberian sculpture, African Negro masks and the art of Cézanne, he turned to compositions of angular planes which developed into Cubism. After a subsequent neoclassical period, a powerful new phase climaxed with the mural *Guernica* in 1937. He continues to produce paintings, sculptures and pottery in many styles simultaneously.

REDON Odilon Redon (1840-1916) was a French painter and lithographer who relied more on the world of dreams, fantasy and a subjective reinterpretation of

reality than on exact observation. He was regarded by the Postimpressionists as a pioneer and a prophet.

ROUAULT

Georges Rouault (1871-1958) was a French painter who developed one of the purest forms of Expressionism although he remained free from all groups and systems of aesthetics. His apprenticeship to a stained-glass window maker is readily apparent in his draughtsmanship. His themes were prostitutes, clowns and judges, religious subjects (chiefly of the Passion), landscapes of a bleak and hostile country and an occasional bouquet of flowers.

SCHIELE

Egon Schiele (1890-1918) based his art on the decorative flat style of Klimt, but surpassed him as a master of the expressive line. He was primarily graphic in his artistic impulse and his completed pictures are hypersensitive drawings overlaid with Expressionist color. The exquisite draughtsmanship of Schiele was the vehicle which carried forward into the twentieth century—almost alone—the unadulterated cultivation of decadence, elegance, the linearity and the over-refinement of the *fin de siècle*.

SCIPIONE

Scipione (1904-1933), whose real name was Gino Bonichi, was the co-founder of the so-called School of Rome, a small group of painters reacting with expressionistic art against certain forms of academism. After illness forced him to abandon plans to be a professional athlete, he turned to painting. It is from his athletic physique that he derived his pseudonym "Scipion."

SCHMIDT-ROTTLUFF

Karl Schmidt-Rottluff (b. 1884) founded Die Brücke with Kirchner and Heckel. His work stands out in German Expressionism because of its monumental style, shown in cube-like landscape compositions and the angular character of his woodcuts. His early work, noted for its heroic mood and violent color, later gave way to a more delicate style, as in his water colors of simple landscape details.

SCHLEMMER

Oskar Schlemmer (1888-1943) was head of the sculpture and scenic design departments of the Bauhaus in Weimar. Like Léger, his paintings depict people, almost like mechanical puppets in appearance, arranged in choreographic fashion within an organized space. But Schlemmer included more spiritual and strongly romantic features. He was once influenced by the 19th-century German Romantic painter, Philipp Otto Runge.

SCHWITTERS Kurt Schwitters (1887-1948) was painter, poet, sculptor and illustrator. The leader of German Dadaism, he produced poetic and fanciful collage pictures which evoke the world of Klee.

SEVERINI Gino Severini (b. 1883) signed the original Futurist Manifesto in 1910 but paid more attention to Cubism. He was greatly influenced by Seurat and Neo-Impressionist theories.

SIGNAC Paul Signac (1863-1935) was a friend and a follower of Seurat. His book, *De Delacroix au Neo-Impressionnisme,* published in 1899, is the textbook of the Neo-Impressionist movement. Signac worked from colored sketches collected on his extensive travels. He aimed to give permanence to a chance impression.

SIRONI Mario Sironi (1885-1961) planned a career in mathematics before turning to art. He experimented for a time in both the Futurist movement and the *Scuola Metafisica* and was an important member of the *Novecento*.

VILLON Jacques Villon (1875-1963), whose real name was Gaston Duchamp, was the brother of Marcel Duchamp and the sculptor, Duchamp-Villon. He began as a Cubist and founded *Section d'Or,* the avant-garde group which was concerned above all with ideal proportions (the "golden mean" or "section"). His painting contained definite constructional elements. Never completely non-figurative, he reduced natural themes to kaleidoscopic surface shapes, relying on color for spatial effects.

VUILLARD Édouard Vuillard (1868-1940) was a French painter who joined the *Nabis* in 1889. His development was strongly influenced by Bonnard. He was an Intimist painter who concentrated on simple, everyday subjects in the home.

WEBER Max Weber (1881-1961) was America's earliest pioneer in modernism. Asserting that he depended on "the great ancients of all races and climes" for inspiration and incentive, his early work evidenced his religious nature with themes of prayer and contemplation and pictures of women suggestive of biblical passages. His later work was characterized by a freely-distorted Naturalism.

Bibliography

GENERAL

Ahlers-Hestermann, F., *Stilwende: Aufbruch der Jugend,* Berlin, 1956.

Apollinaire, G., *The Cubist Painters,* Paris, 1913, reprinted 1944.

Brion, M., *L'Art Abstrait,* Paris, 1956.

Bru, C. P., *Esthétique de l'Abstraction,* Paris, 1955.

Canaday, J., *Mainstreams of Modern Art: David to Picasso,* New York, 1962.

Cassou, J., and Jaccottet, P., *Les Dessin français au XX⁰ siècle,* Lausanne, 1951.

Chassé, C., *Le Movement Symboliste,* Paris, 1947.

Clark, K., *The Nude: A Study in Ideal Form,* New York, 1956.

Dodgson, C., *Modern Drawings,* London, 1933.

Dorival, B., *Les Étapes de la Peinture Française Contemporaine,* Paris, 1943-46.

Dorival, B., *Les Peintres du XX⁰ siècle,* Paris, 1957.

Escholier, R., *La Peinture française: XX⁰ siècle,* Paris, 1937.

Fry, R., *Characteristics of French Art,* London, 1932.

Gleizes, A., and Metzinger, J., *Du Cubisme,* Paris, 1912, reprinted 1947.

Golding, J., *Cubism,* New York, 1959.

Gray, C., *Cubist Aesthetic Theories,* New York, 1953.

Grohmann, W., *The Expressionists,* New York, 1962.

Hitchcock, H. R., *Architecture: 19th and 20th Centuries,* London, 1958.

Humbert, A., *Les Nabis et Leur Époque,* Geneva, 1954.

Hunter, S., *Modern French Painting,* New York, 1956.

Jammer, M., *Concepts of Space,* New York, 1954.

Jammer, M., *Concepts of Force,* New York, 1957.

Kahnweiler, D. H., *The Rise of Cubism,* New York, 1949.

Kuhn, C., *German Expressionism and Abstract Art: The Harvard Collections,* Cambridge, Mass., 1957.

Le Corbusier, *The New World of Space,* New York, 1948.

Lenning, H. F., *The Art Nouveau,* New York and London, 1951.

Lhote, A., *La Peinture Libérée,* Paris, 1956.

Madsen, S. T., *Sources of Art Nouveau,* New York, 1955.

Michel, G., *Modern French Painting,* New York, 1940.

Mondrian, P., *Plastic Art and Pure Plastic Art,* New York, 1945.

Mongan, A., and Sachs, P. J., *Drawings in the Fogg Museum of Art,* 2 vols., Cambridge, Mass., 1940.

Myers, B. S., *The German Expressionists: A Generation in Revolt,* New York, n.d.

Pevsner, N., *Pioneers of the Modern Movement,* New York, 1936.

Rewald, J., *Post-Impressionism,* New York, n.d.

Rosenberg, J., *Great Draughtsmen from Pisanello to Picasso,* Cambridge, Mass., 1959.

Rosenblum, R., *Cubism and Twentieth-Century Art,* New York, 1962.

Sachs, P. J., *Modern Prints and Drawings,* New York, 1954.

Schmalenbach, F., *Jugendstil,* Wuerzburg, 1934.

Selz, P., *German Expressionist Painting,* Berkeley, 1957.

Seuphor, M., *L'Art Abstrait,* Paris, 1949.

Seuphor, M. (ed.), *Dictionary of Abstract Painting,* New York, 1957.

Seuphor, M., *Abstract Painting: Fifty Years of Accomplishment, from Kandinsky to the Present,* New York, 1963.

Sypher, W., *Rococo to Cubism in Art and Literature,* New York, 1960.

Taylor, J. C., *Futurism,* New York, 1961.

Trier, E., *Zeichner des XX Jahrhunderts,* Berlin, 1956.

Valsecchi, M., *The Italian Moderns,* New York, 1962.

Van Lier, H., *Les Arts de l'Espace,* Tournai, 1959.

Venturi, L., *Modern Painters,* New York, 1947.

Wheeler, M., *Modern Drawings,* Museum of Modern Art, New York, 1944.

BECKMANN

Goepel, E., *Max Beckmann der Zeichner,* Munich, 1962.

BOCCIONI

Argan, G. A., *Umberto Boccioni,* Rome, 1953.

Taylor, J. C., *The Graphic Work of Umberto Boccioni,* New York, 1961.

BRANCUSI

Zervos, C., *Constantin Brancusi,* Paris, 1957.

BRAQUE

Brion, M., *Braque,* New York, 1962.

Cassou, J., *Braque,* New York, 1962.

Hofmann, W., *Georges Braque: His Graphic Work,* New York, 1963.

Ponge, F. (ed.), *Braque: Dessins,* Paris, 1950.

CHAGALL

Ayrton, M., *Chagall,* London, 1948.

Brion, M., *Chagall,* New York, 1961.

Meyer, F., *Marc Chagall: His Graphic Work,* New York, 1962.

Schmidt, G., *Marc Chagall: Gouaches,* New York, 1962.

CHIRICO

Soby, J. T., *Giorgio de Chirico,* New York, 1955.

CORINTH

Biermann, G., *Der Zeichner Lovis Corinth,* Dresden, 1924.

DALI

Descharnes, R., *The World of Salvador Dali,* New York, 1962.

DEMUTH

Murrell, W., *Charles Demuth,* New York, n.d.

Ritchie, A., *Charles Demuth,* New York, 1950.

DERAIN

Fauré, E., *André Derain,* Paris, 1923.

DIX

Loeffler, F., *Otto Dix,* Dresden, n.d.

DUCHAMP

Duchamp, M., *Boîte-en-Valise,* New York, 1941-42.

Lebel, R., *Marcel Duchamp,* New York, 1959.

DUFY

Courthion, P., *Raoul Dufy,* Geneva, 1952.

Hunter, S., *Dufy,* New York, 1962.

DUNOYER DE SEGONZAC

Jamot, P., *Dunoyer de Segonzac,* Paris, 1929.

FEININGER

Hess, H., *Lyonel Feininger,* New York, 1962.

GRIS

Kahnweiler, D. H., *Juan Gris: sa vie, son oeuvre, ses écrits,* Paris, 1946.

Soby, J. T., *Juan Gris,* New York, 1958.

GROSZ

Grosz, G., *George Grosz Drawings,* New York, 1944.

JOHN

Browse, L., *Augustus John Drawings,* London, 1941.

KANDINSKY

Brion, M., *Kandinsky,* New York, 1962.

Grohmann, W., *Kandinsky,* New York, 1958.

KIRCHNER

Grohmann, W., *E. L. Kirchner,* Stuttgart, 1958.

KLEE

Brion, M., *Klee,* Paris, 1955.

Grohmann, W., *The Drawings of Paul Klee (1921-1930),* New York, 1944.

Grohmann, W., *Paul Klee Drawings,* New York, 1962.

Haftmann, W., *Paul Klee: Watercolors, Drawings, Writings,* New York, 1962.

KLIMT

Eisler, M., *Gustave Klimt,* Vienna, 1920.

KOKOSCHKA

Bultmann, B., *Oskar Kokoschka,* New York, 1963.

Russeu, J., *Oskar Kokoschka: Watercolors, Drawings, Writings,* New York, 1963.

Westheim, P., *Kokoschka Handzeichnungen,* Berlin, n.d.

KOLLWITZ

Bittner, H., *Kaethe Kollwitz Drawings,* New York, 1960.

Klipstein, A., *Kaethe Kollwitz,* Bern, 1955.

Zigrosser, C., *Kaethe Kollwitz,* New York, 1946.

LÉGER

Maurois, A., *Mon Ami Léger,* Paris, 1952.

MACKE

Vriesen, G., *August Macke,* Stuttgart, 1953.

MANZU

Argan, G. A., *Manzu: disegni,* Bergamo, 1948.

MARC

Lankheit, K., *Franz Marc: Watercolors, Drawings, Writings,* New York, 1962.

MARCOUSSIS

Lafranchis, J., *Marcoussis,* Paris, 1961.

MATISSE

Barr, A. H., Jr., *Matisse: His Art and His Public,* New York, 1951.

Greenberg, C., *Matisse,* New York, 1962.

Humbert, A., *Henri Matisse: dessins,* Paris, 1956.

Seckel, C., *Henri Matisse,* Tuebingen, 1956.

MIRÓ

Dupin, J., *Miró,* New York, 1963.

Hunter, S., *Joan Miró: His Graphic Work,* New York, 1962.

Soby, J. T., *Joan Miró,* New York, 1959.

MODIGLIANI

Lipchitz, J., *Amedeo Modigliani,* New York, 1952.

Pfannstiel, A., *Modigliani et son Oeuvre,* Paris, 1956.

Roy, C., *Modigliani,* New York, 1958.

MONDRIAN

Hunter, S., *Mondrian,* New York, 1962.

Seuphor, M., *Piet Mondrian,* New York, 1957.

NOLDE

Haftmann, N., *Nolde,* New York, 1962.

OROZCO

Reed, A., *José Clemente Orozco,* New York, 1932.

PASCIN

Werner, A., *Jules Pascin,* New York, 1963.

PICABIA

Buffet-Picabia, G., *Some Memories of Pre-Dada: Picabia and Duchamp,* New York, 1949.

PICASSO

Arnheim, R., *Picasso's Guernica: The Genesis of a Painting,* Berkeley and Los Angeles, 1962.

Barr, A. H., Jr., *Picasso: Fifty Years of His Art,* New York, 1946.

Boudaille, G., *Picasso's Sketchbook,* New York, 1962.

Eluard, P., *Picasso: Dessins,* Paris, 1952.

Geiser, B., *Picasso: Fifty-five Years of His Graphic Work,* New York, 1962.

Jardot, M., *Pablo Picasso Drawings,* New York, 1959.

REDON

Boucou, R., *Odilon Redon,* Geneva, 1956.

Sandstrom, S., *Le Monde Imaginaire d'Odilon Redon,* Paris, 1955.

ROUAULT

Courthion, P., *Georges Rouault,* New York, 1961.

Jewell, E. A., *Georges Rouault,* New York, 1945.

Maritain, J., *Rouault,* New York, 1962.

Venturi, L., *Rouault,* Geneva, 1959.

SCHIELE

Benesch, O., *Egon Schiele as a Draughtsman,* Vienna, 1950.

SCIPIONE

Marchiori, G., *Disegni di Scipione,* Bergamo, 1954.

SEVERINI

Courthion, P., *Gino Severini,* Milan, 1930.

SIRONI

Pica, A., *Mario Sironi, Painter,* Milan, 1955.

VUILLARD

Salomon, J., *Auprès de Vuillard,* Paris, 1953.

WEBER

Cahill, H., *Max Weber,* New York, 1930.